Sarnia Ontario Book 3 in Colour Photos, Saving Our History One Photo at a Time

Photography by Barbara Raué
2015

Series Name:
Cruising Ontario

Book 135: Sarnia Book 3

Cover photo: 261 London Road, Page 29

Series Name: Cruising Ontario
Saving Our History One Photo at a Time
in colour photos

Books Available in Alphabetical Order:
Aberfoyle, Acton, Alton, Ancaster, Arthur, Aylmer, Ayr, Bloomingdale, Brantford, Burlington, Caledon, Caledonia, Cambridge, Clifford, Conestogo, Delhi, Dorchester to Aylmer, Drayton, Drumbo, Dundas, Eden Mills, Elmira, Elora, Fergus, Guelph, Hagersville, Hamilton, Hanover, Harriston, Hespeler, Jarvis, Kitchener, Linwood, Listowel, London, Lucknow, Mono, Mount Forest, Neustadt, New Hamburg, Niagara-on-the-Lake, Oakville, Orangeville, Orillia, Owen Sound, Palmerston, Peterborough, Port Elgin, Preston, Rockwood, Seaforth, Sheffield, Shelburne, Simcoe, Southampton, St. Jacobs, St. Thomas, Stoney Creek, Stratford, Tillsonburg, Waterdown, Waterrford, Waterloo, Wellesley, Wingham

Book 110:Lucknow,Mitchell
Book 111: Conestogo, Bloomingdale
Book 112: Delhi
Book 113: Waterford
Book 114-116: Waterloo
Book 117-119: Windsor
Book 120-121: Amherstburg
Book 122: Essex
Book 123-124: Kingsville
Book 125-127: Woodstock
Book 128: Thamesford
Book 129-132: St. Mary's
Book 133-136: Sarnia

Other Books by Barbara Raue

Coins of Gold

Arrows, Indians and Love

The Life and Times of Barbara
Volume 1: Inventions That Have Enhanced My Life
Volume 2: Entertainment That I Have Enjoyed
Volume 3: East Coast Trips
Volume 4: Olympics Have Always Intrigued Me
Volume 5: Wonders of the World
Volume 6: Caribbean Cruises We Have Enjoyed
Volume 7: Animals
Volume 8: Storms and Other Major Disasters in My Lifetime
Volume 9: Wars, Terrorist Attacks and Major Disasters

The Cromwell Family Book

Laura Secord Discovered

Daddy Where Are You?

Visit Barbara's website to view all of her books
http://barbararaue.ca

Sarnia is a city in Southwestern Ontario located on the eastern bank of the junction between the Upper and Lower Great Lakes where Lake Huron flows into the St. Clair River, which forms the Canada-United States border, directly across from Port Huron, Michigan.. It is the largest city on Lake Huron. The city's natural harbor first attracted the French explorer LaSalle, who named the site "The Rapids" when he had horses and men pull his forty-five-ton barque "Le Griffon" up the almost four-knot current of the St. Clair River in August 1679. This was the first time anything other than a canoe or other oar-powered vessel had sailed into Lake Huron.

The name "Sarnia" is Latin for Guernsey, which is a British Channel Island. In 1829 Sir John Colborne, a former governor of Guernsey, was appointed Lieutenant Governor of Upper Canada. In this capacity, he visited two small settlements in 1835 that had been laid out on the shores of Lake Huron. One of these, named "The Rapids," consisted then of 44 taxpayers, nine frame houses, four log houses, two brick dwellings, two taverns and three stores. Sir John Colborne suggested a name change to Port Sarnia. Sarnia adopted the nickname "The Imperial City" on May 7, 1914 because of the visit of Canada's Governor General, H.R.H. the Duke of Connaught, and his daughter Princess Patricia.

Table of Contents

Green Street	Page 6
Johnston Street	Page 10
London Road	Page 11
Mackenzie Street	Page 32
Maria Street	Page 35
Maxwell Street	Page 40
Napier Street	Page 41
Penrose Street	Page 41
Queen Street	Page 42
Rose Street	Page 50
Samuel Street	Page 50
Savoy Street	Page 51
Stuart Street	Page 52
Architectural Terms	Page 54
Building Styles	Page 58

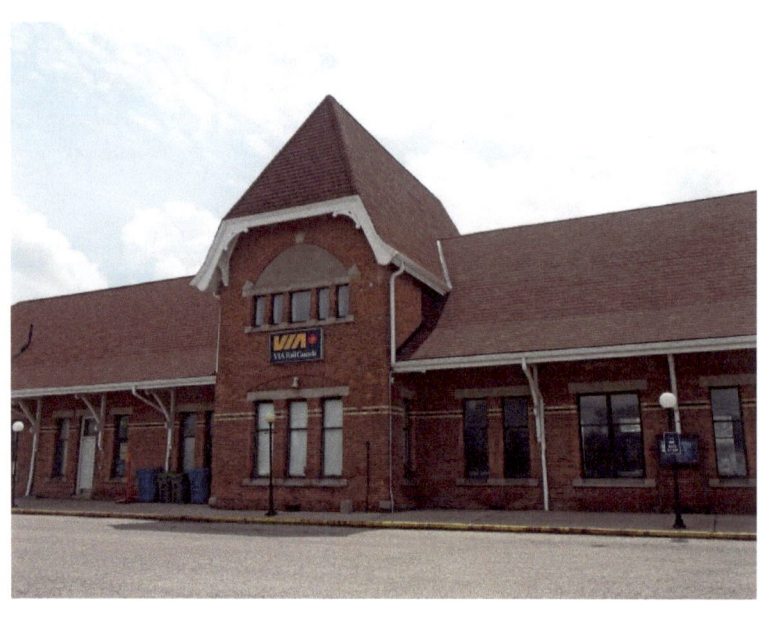

125 Green Street – 1890 – former Canadian National Railway Station – now VIA Station

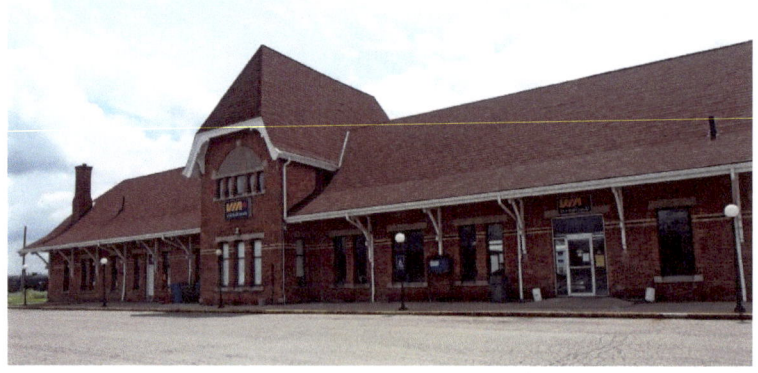

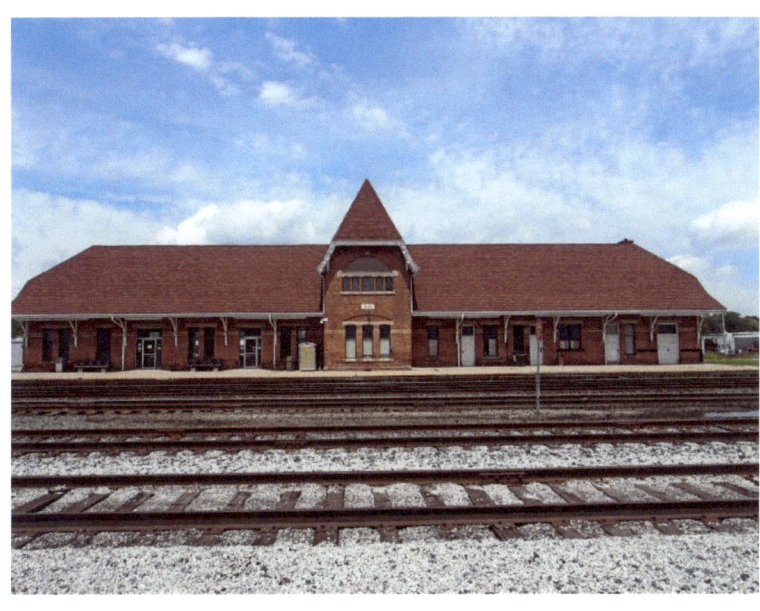

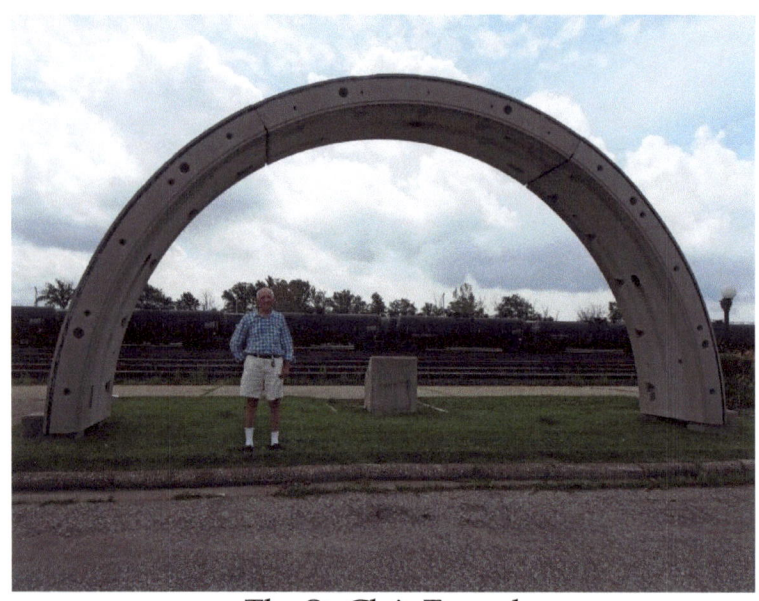

The St. Clair Tunnel
Shield driven in compressed air and lined with cast-iron segments

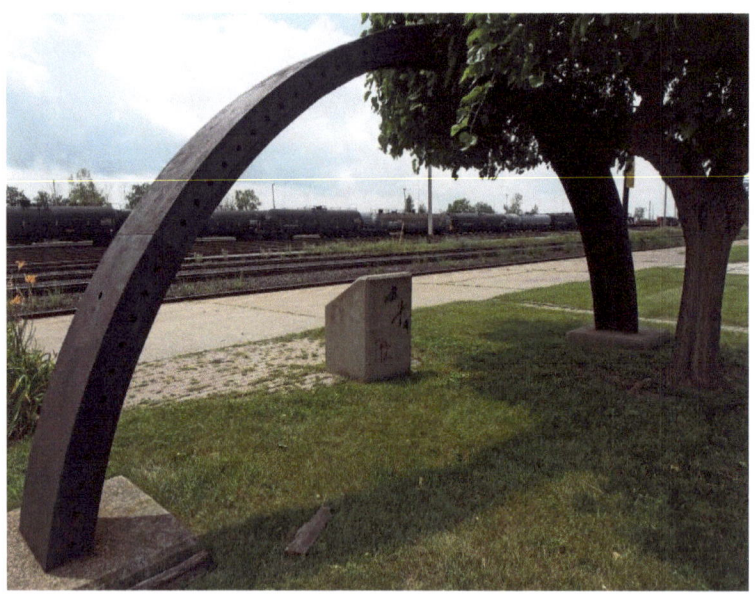

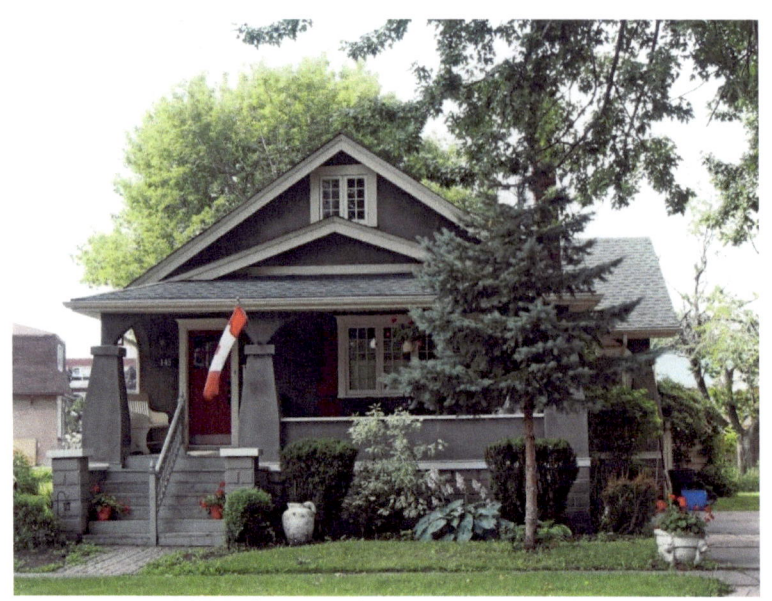

145 Johnston Street - vernacular

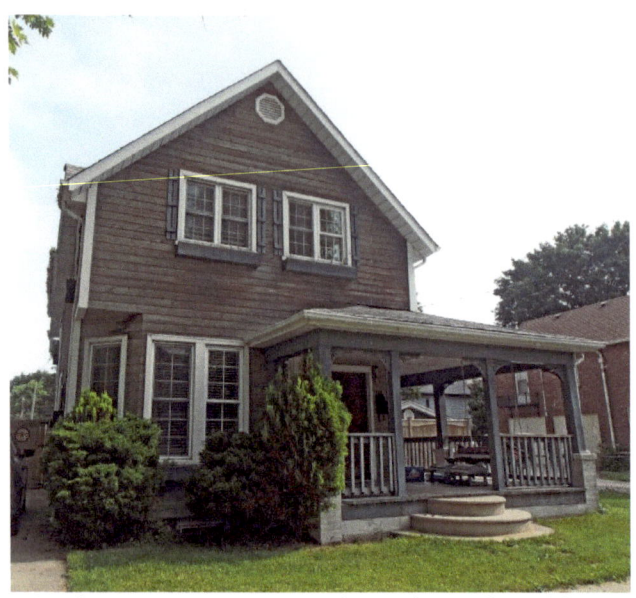

146 Johnston Street – Gothic – board and batten

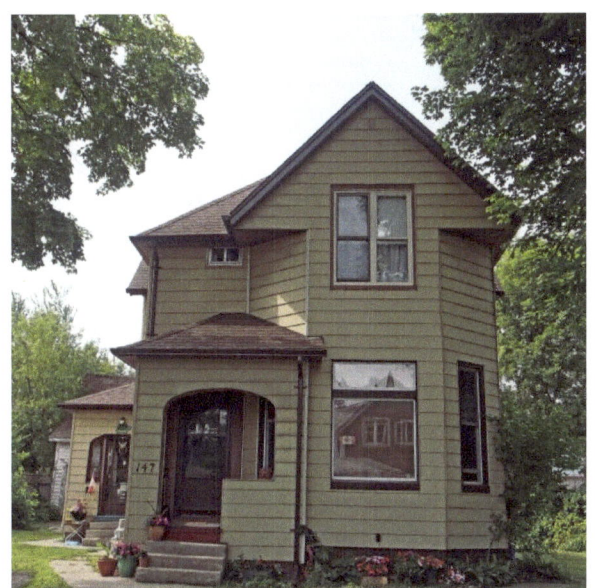

147 Johnston Street

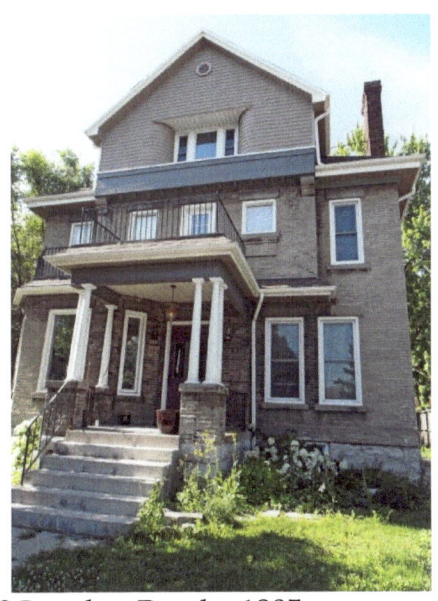

183 London Road – 1905 - vernacular

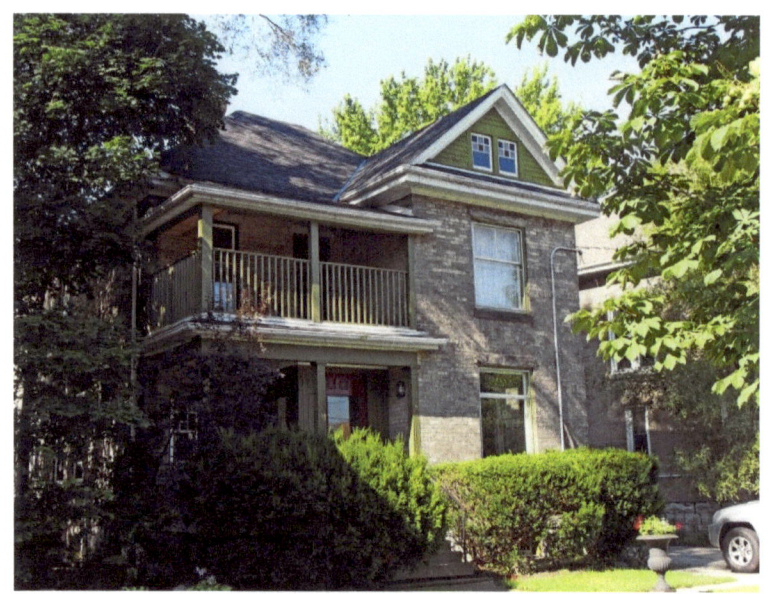
187 London Road - 1904

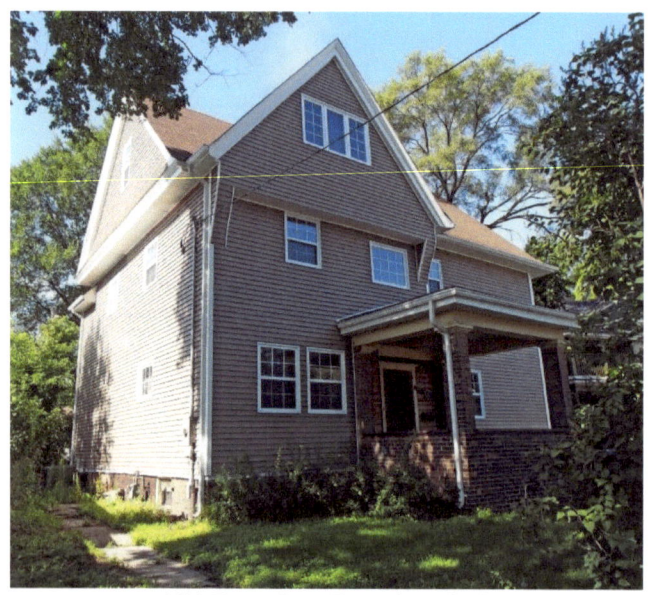
191 London Road - 1910

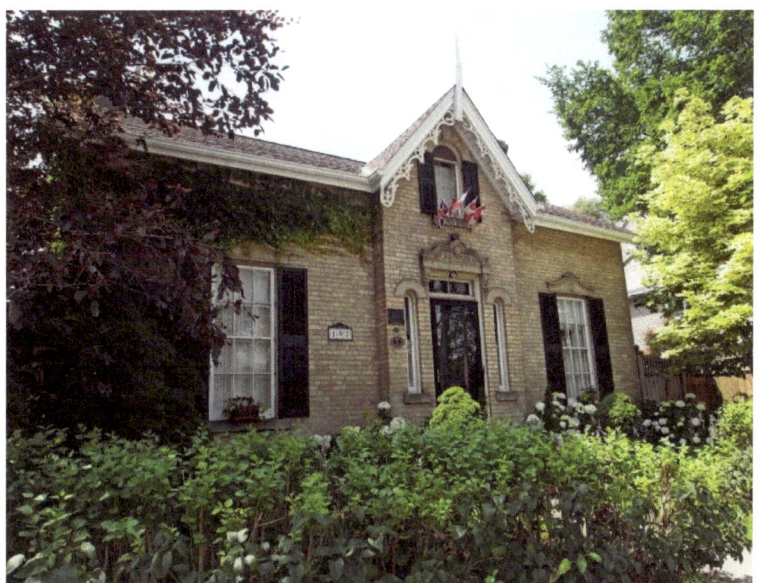

197 London Road, Mulberry House 1867 – Gothic/Georgian style - 1½ storey yellow brick home, stone foundation; centred on the façade is a frontispiece with a gable roof

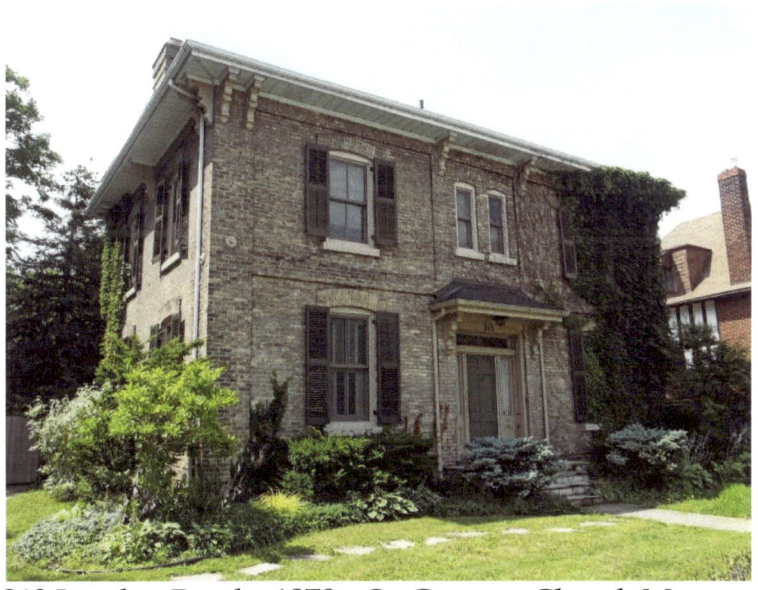

213 London Road – 1870 – St. Georges Church Manse – Italianate, cornice brackets, sidelights – yellow brick

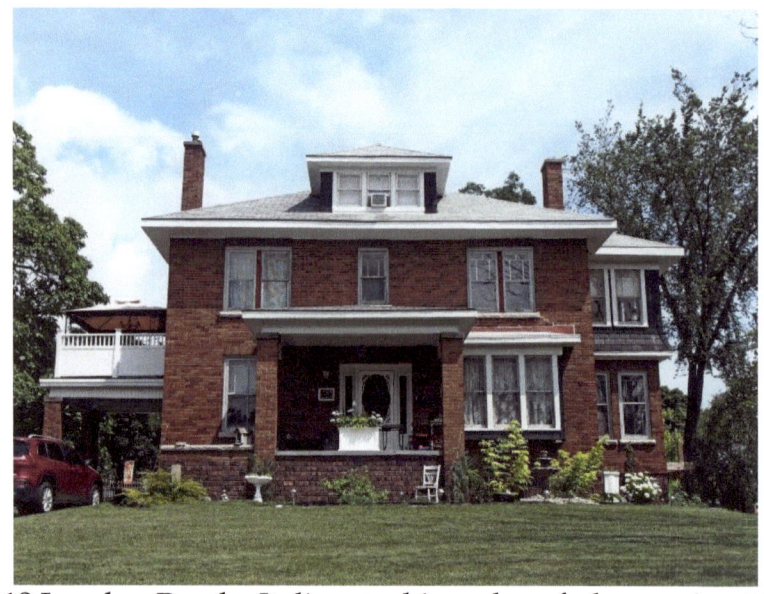

218 London Road – Italianate, hipped roof, dormer in attic

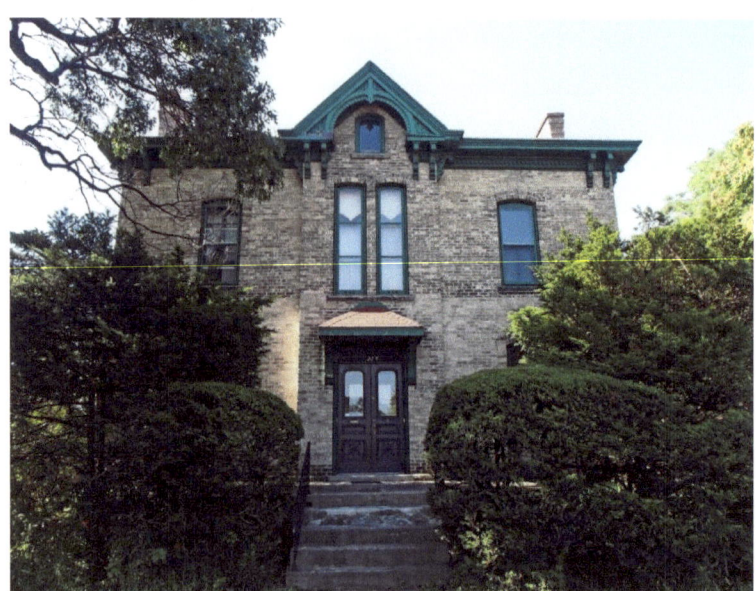

223 London Road – 1880 – Italianate - three bay, two storey yellow brick house with a centred frontispiece topped by a gable with a semi-circular arch decorated with bargeboard

481-483 London Road - 1880

Corner quoins, hipped roof

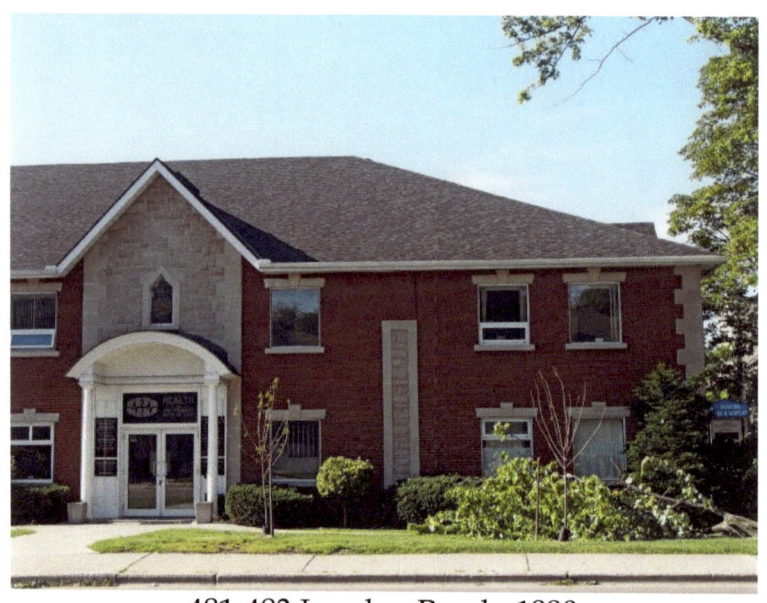

481-483 London Road - 1880

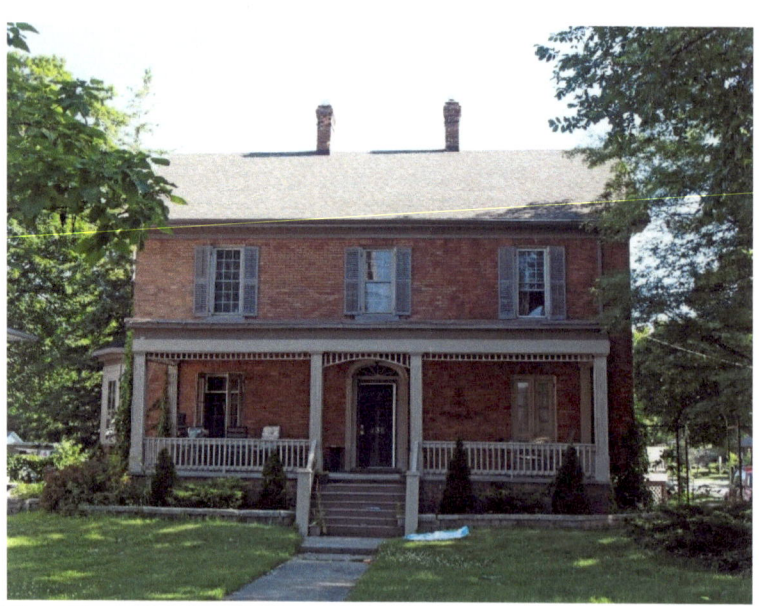

438 London Road – 1900 – Georgian, transom window above door, bay window on side

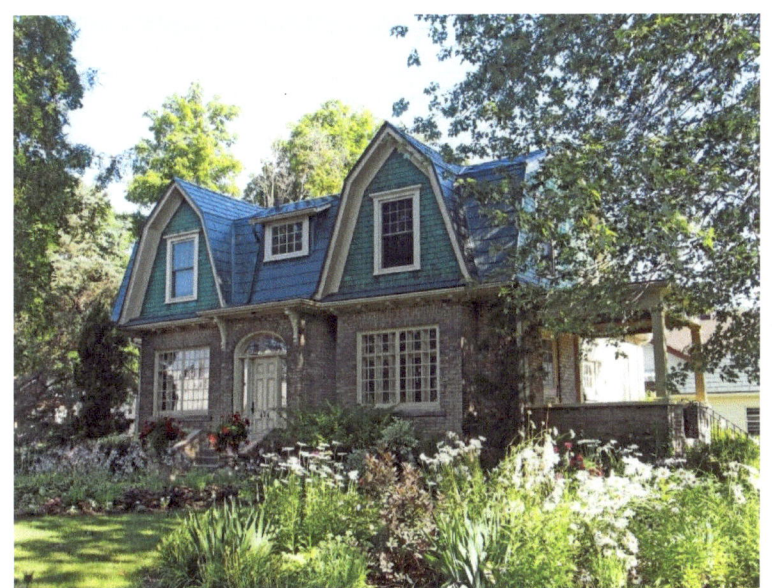

424 London Road – 1911 – gambrel roofed gables, sidelights and transom

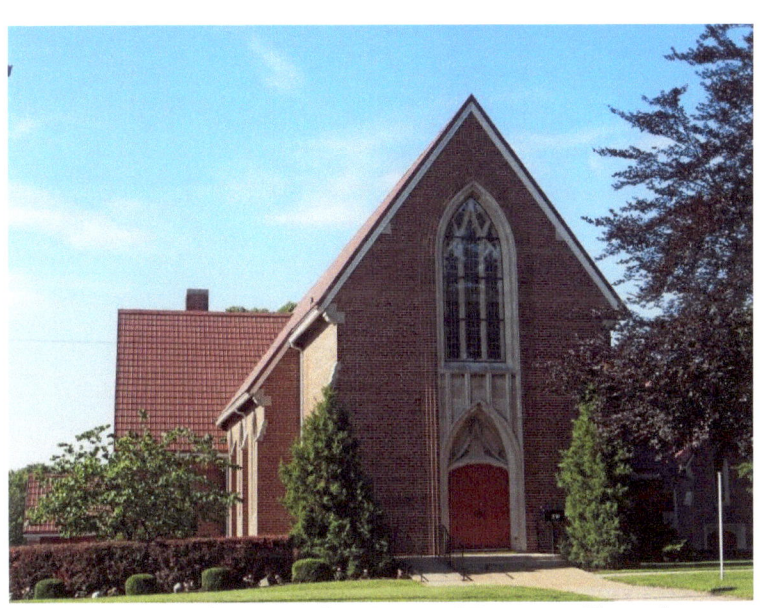

391 London Road – Central Baptist Church

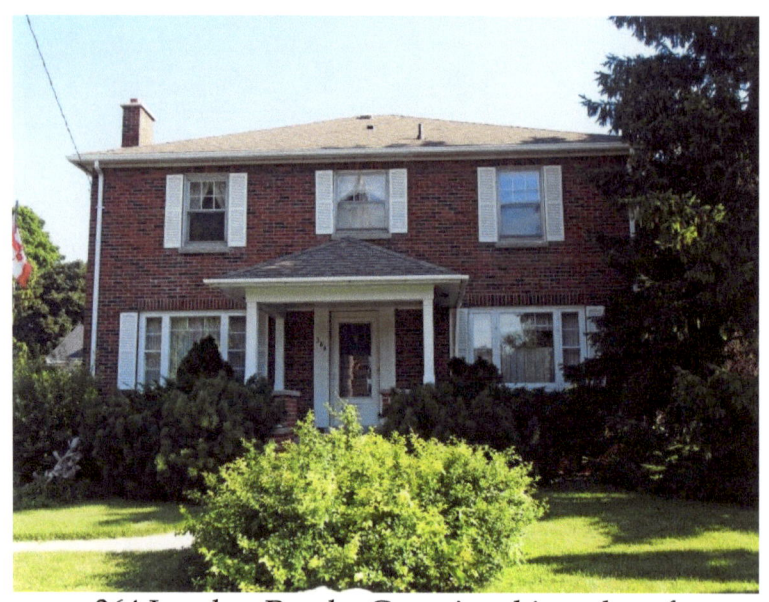

364 London Road – Georgian, hipped roof

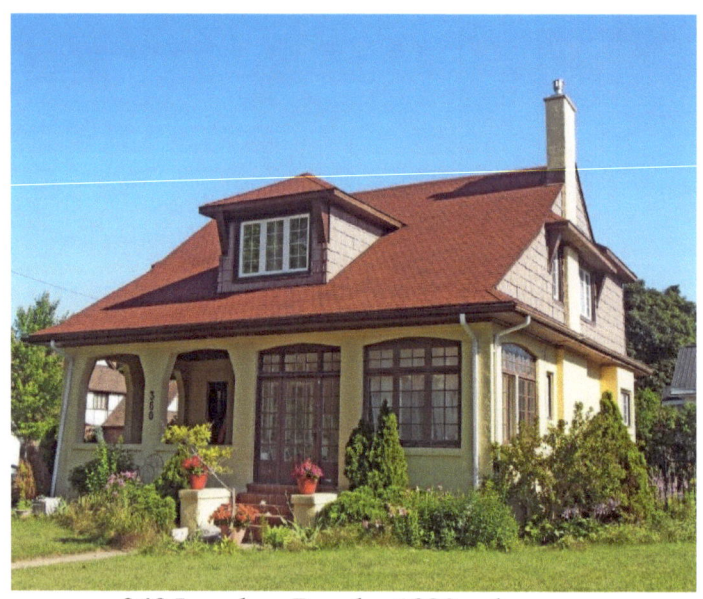

360 London Road – 1920 - dormer

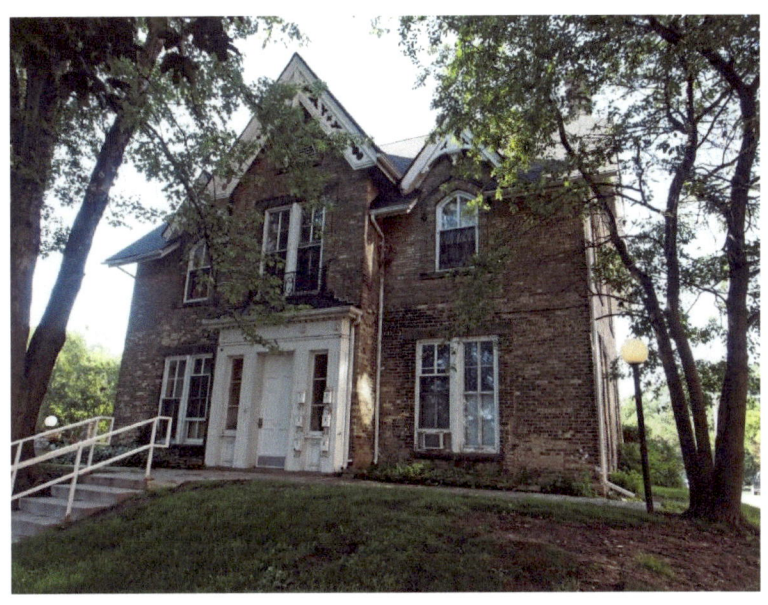

361 London Road – 1870 – Gothic Revival - lacey bargeboard

Voussoirs

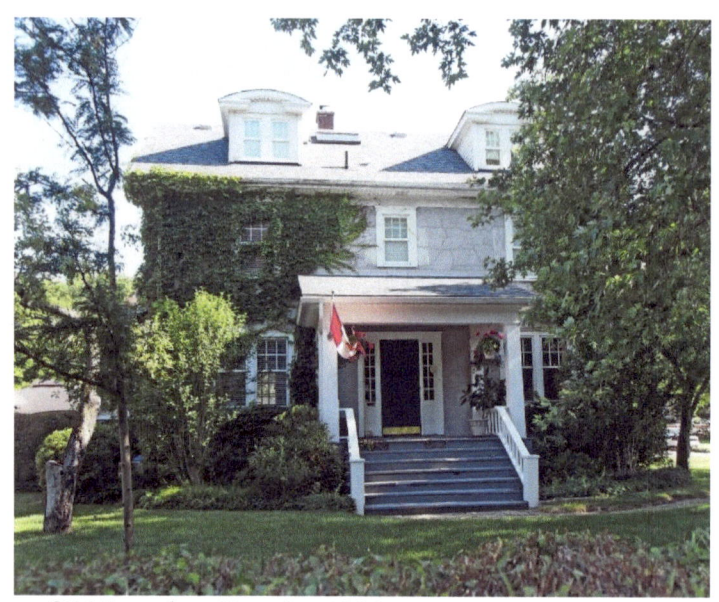

354 London Road – 1920 – Georgian, dormers

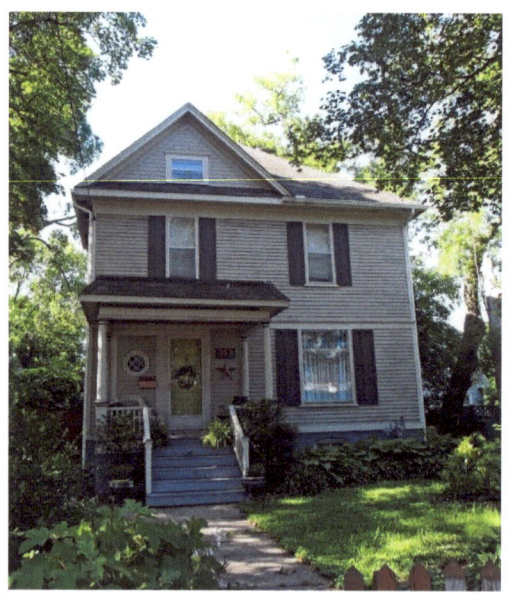

343 London Road – 1900 – Edwardian

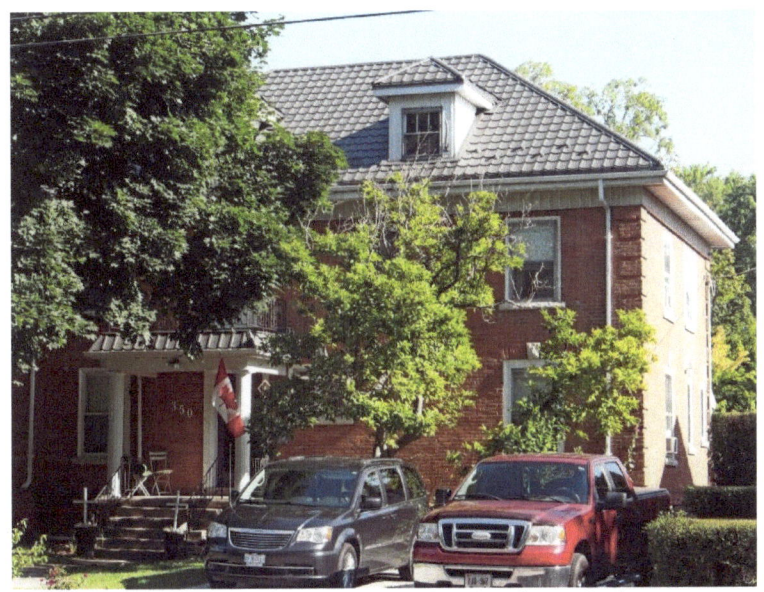

350 London Road – 1910 – hipped roof, dormer

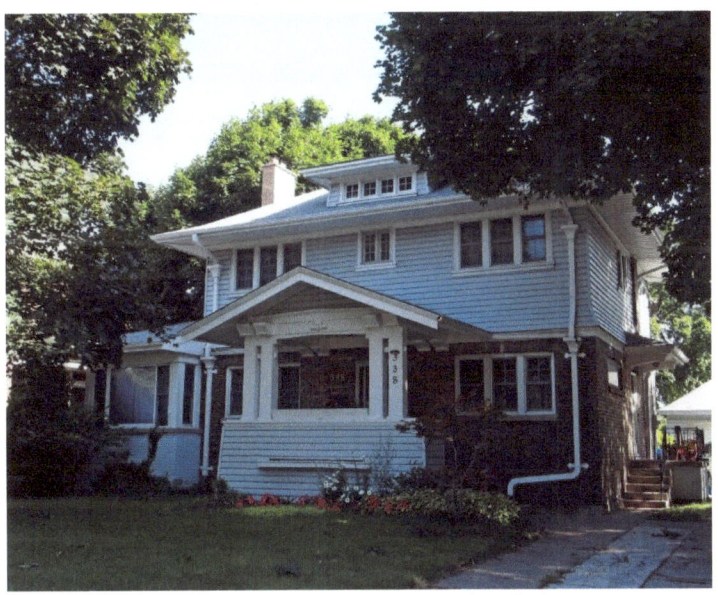

338 London Road – 1910 – shed dormer

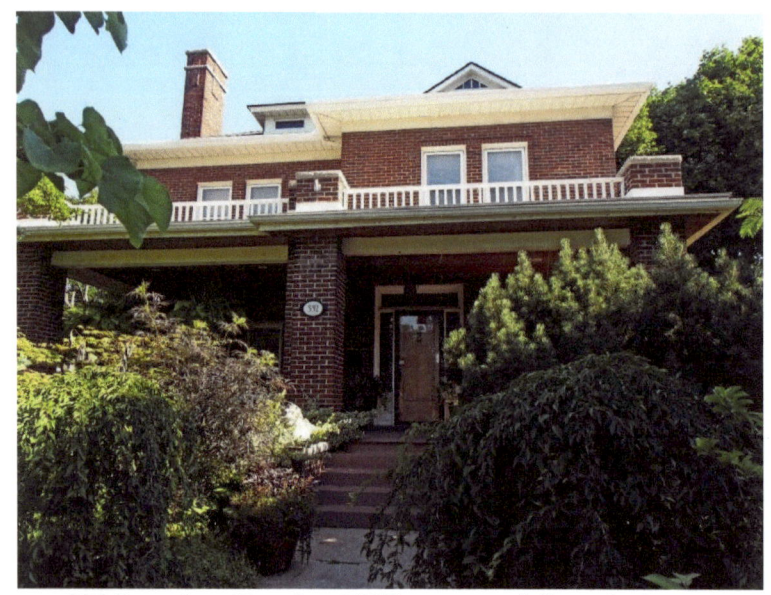

332 London Road – 1915 – second floor balcony

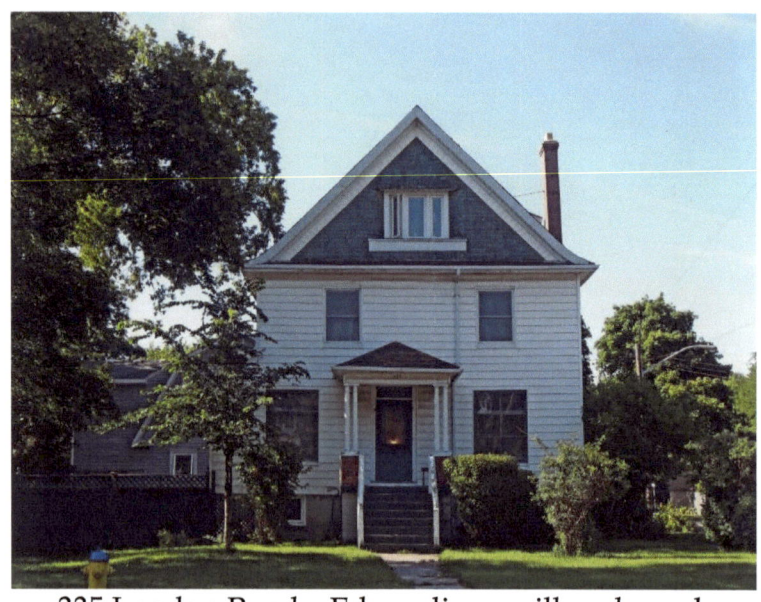

335 London Road – Edwardian – pillared porch

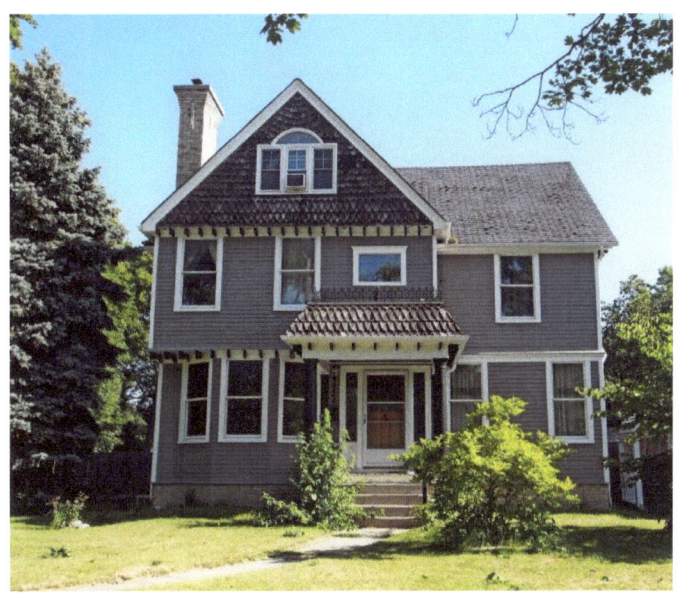

322 London Road – 1904 – Edwardian – Palladian window, fish scale patterning in gable, cornice brackets, iron cresting above entrance, sidelights

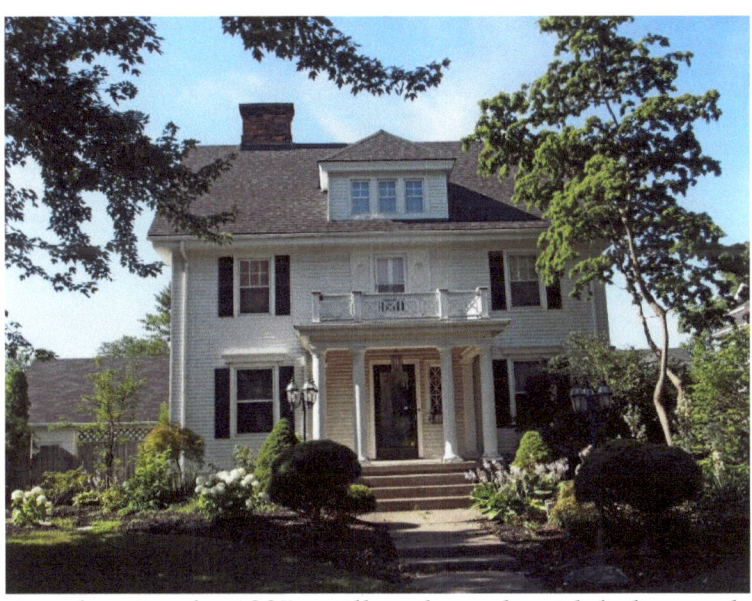

321 London Road – 1895 – pillared porch with balcony above

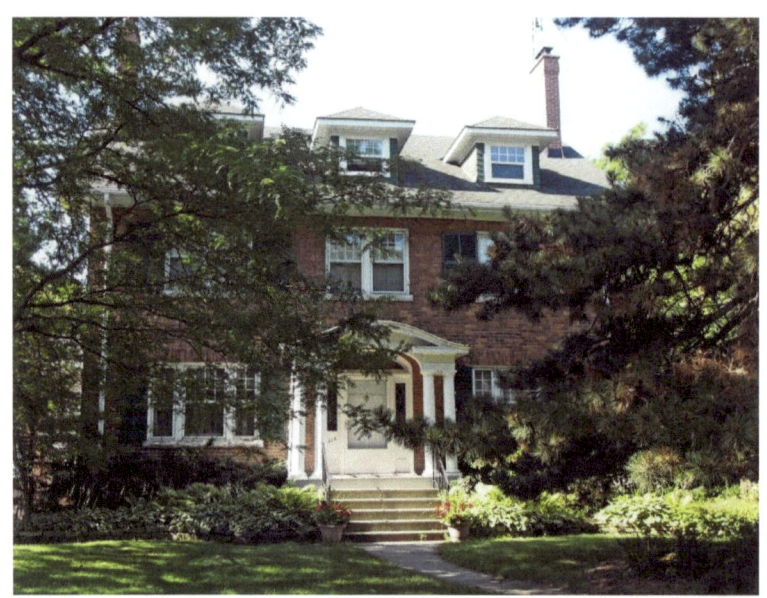

315 London Road – 1913 – Georgian, pillared porch, dormers

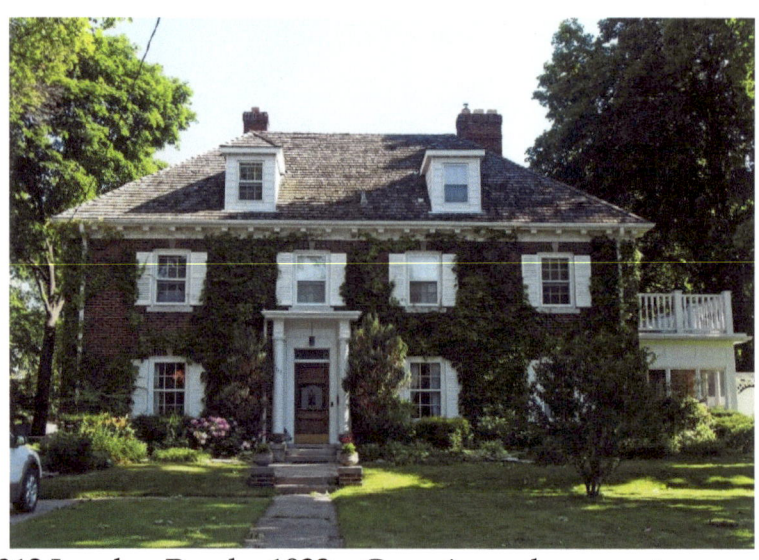

312 London Road – 1922 – Georgian – dormers, transom window

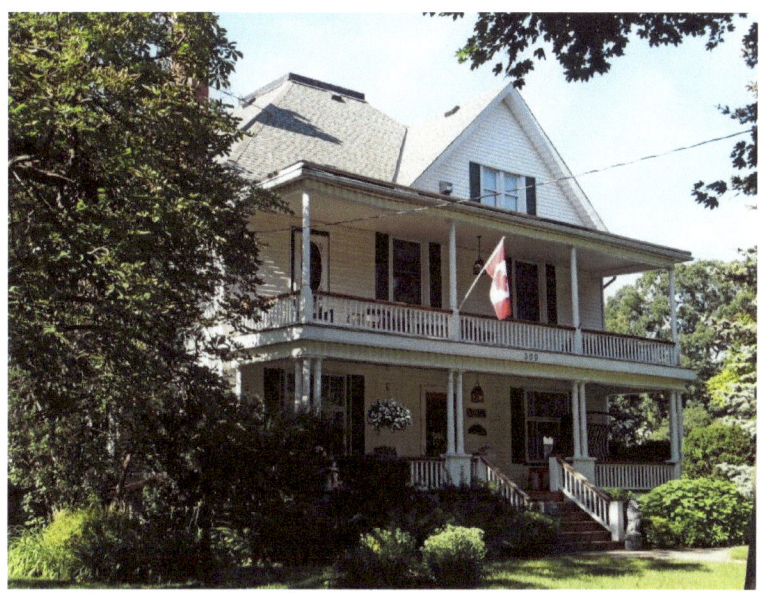

309 London Road – 1900 – two-storey verandah

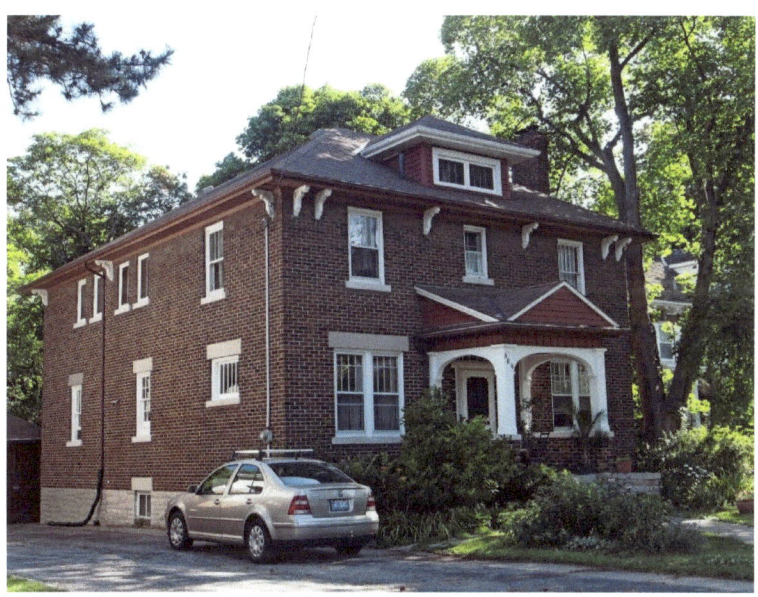

306 London Road – 1920 – Italianate, hipped roof, dormer, cornice brackets

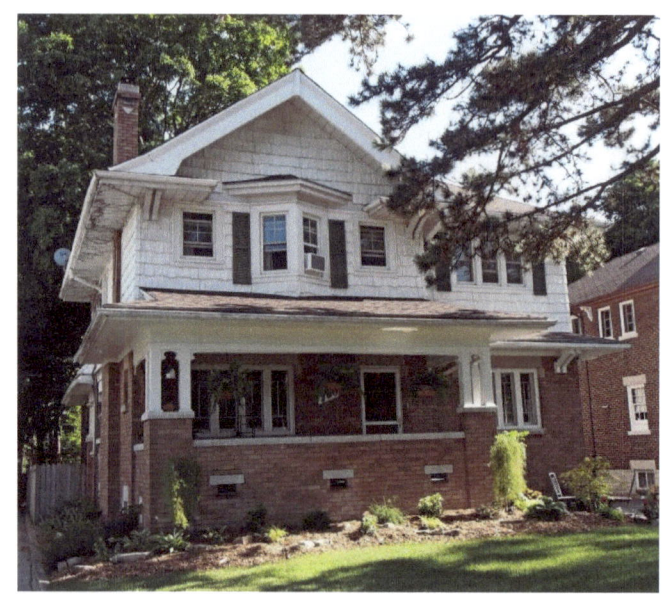

300 London Road – 1910 – cornice brackets

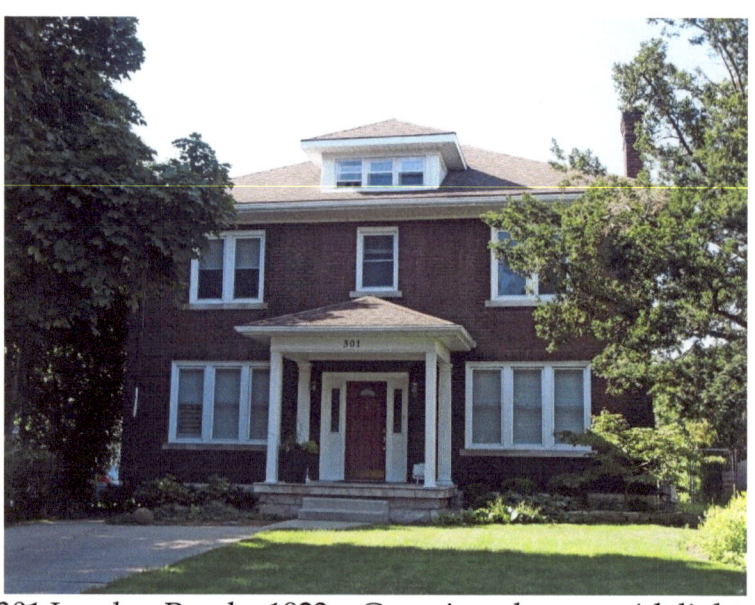

301 London Road – 1923 – Georgian, dormer, sidelights

297 London Road – 1915 – Georgian/Tudor

Dormer between gables, voussoir with keystone above door

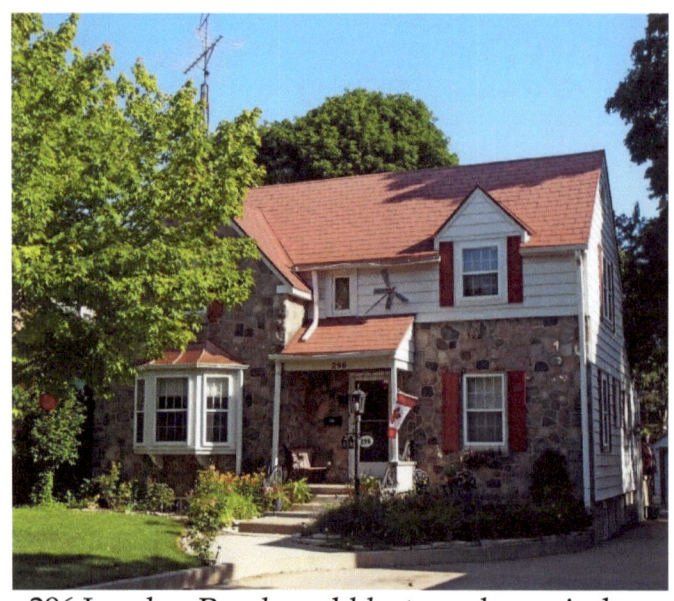

296 London Road – cobblestone, bay window

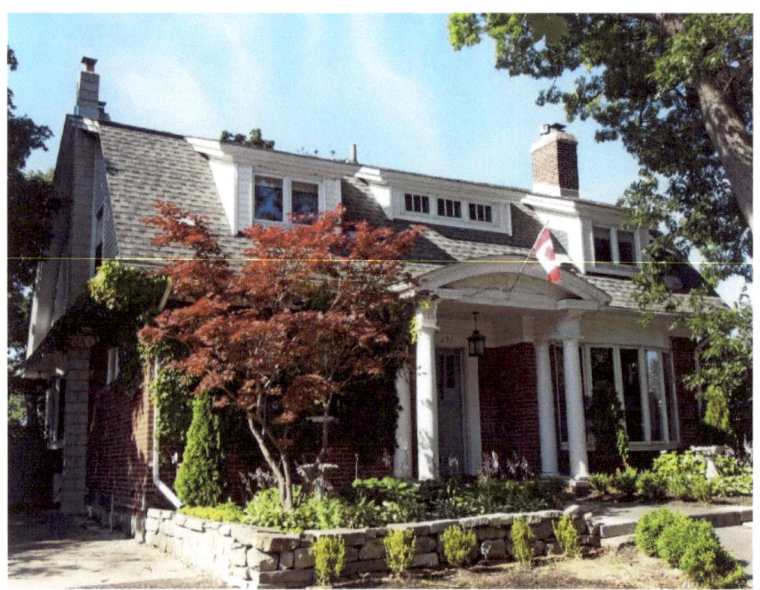

291 London Road – 1915 – gambrel roof, shed dormers, pillared entrance with curved pediment

269 London Road – 1860 - Gothic

261 London Road – 1925 – Georgian – voussoirs with keystones, sidelights

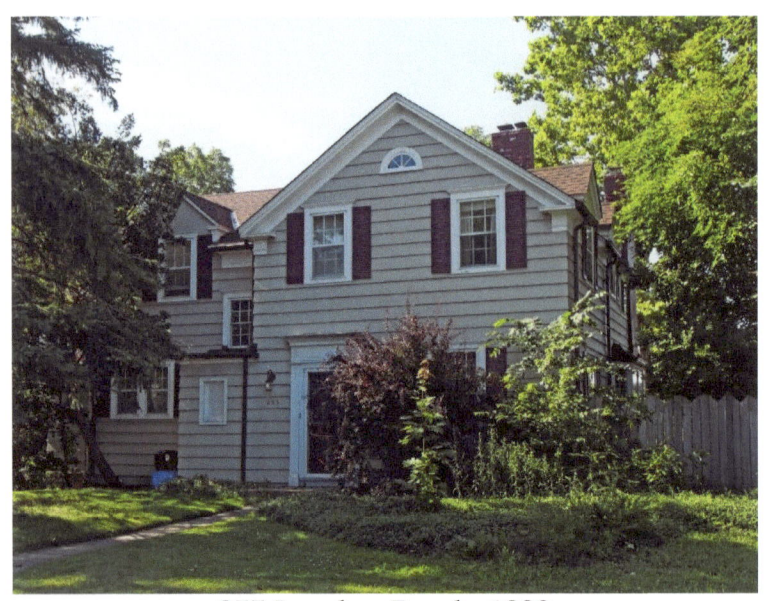

255 London Road - 1890

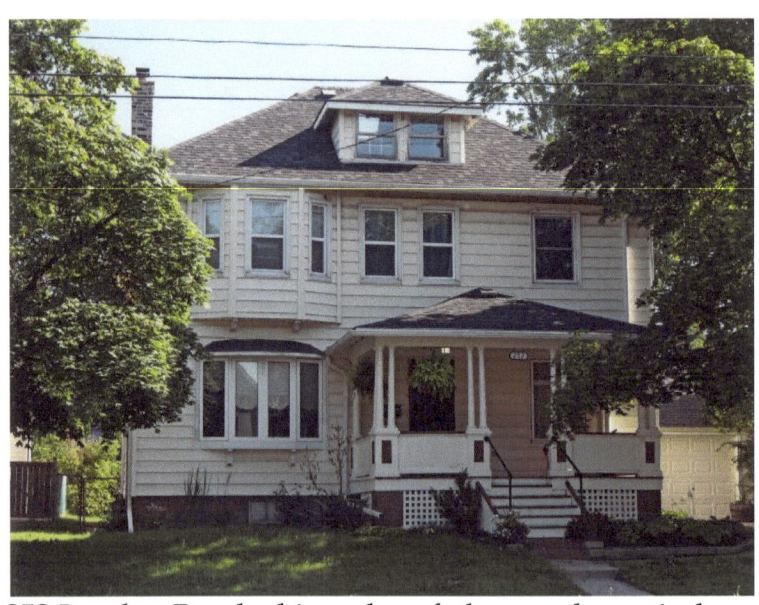

252 London Road – hipped roof, dormer, bay windows

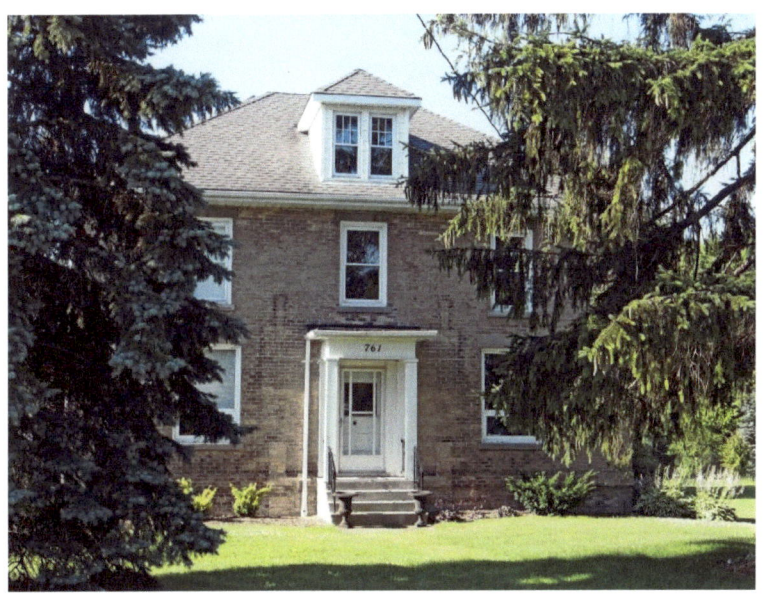

761 London Road – dormer in hipped roof

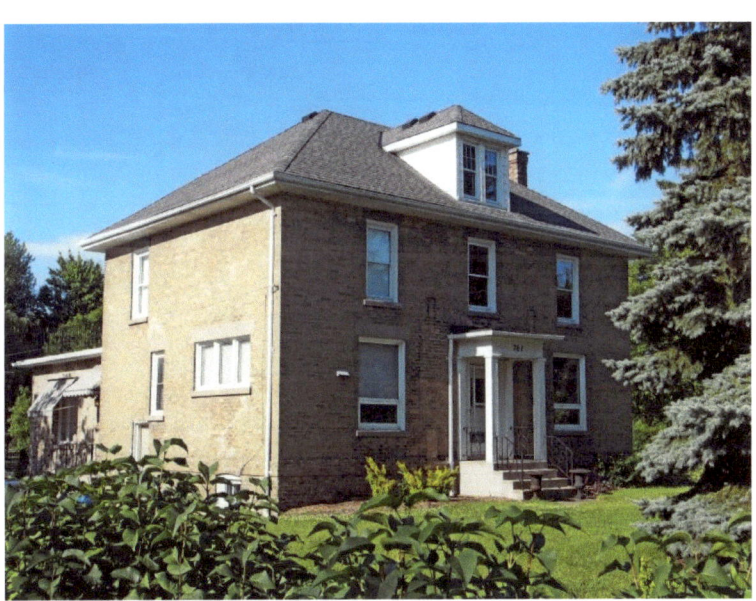

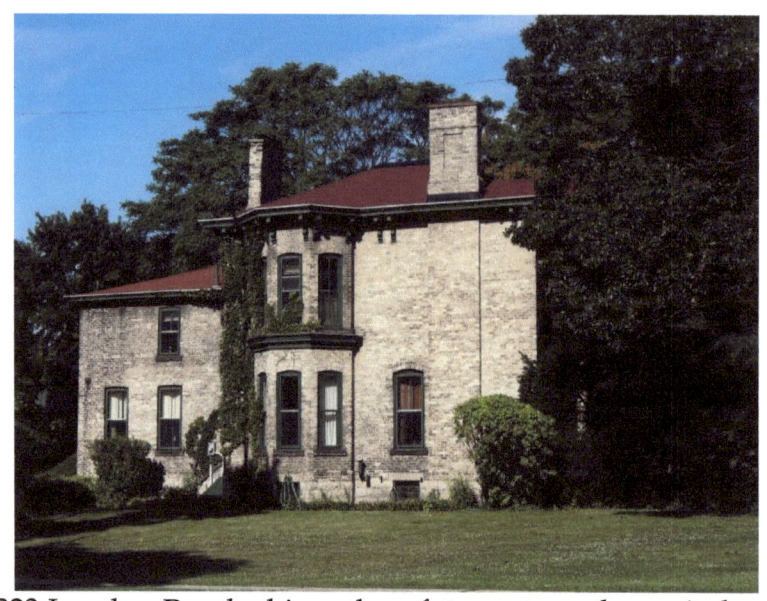

223 London Road – hipped roof, two-storey bay window, cornice brackets

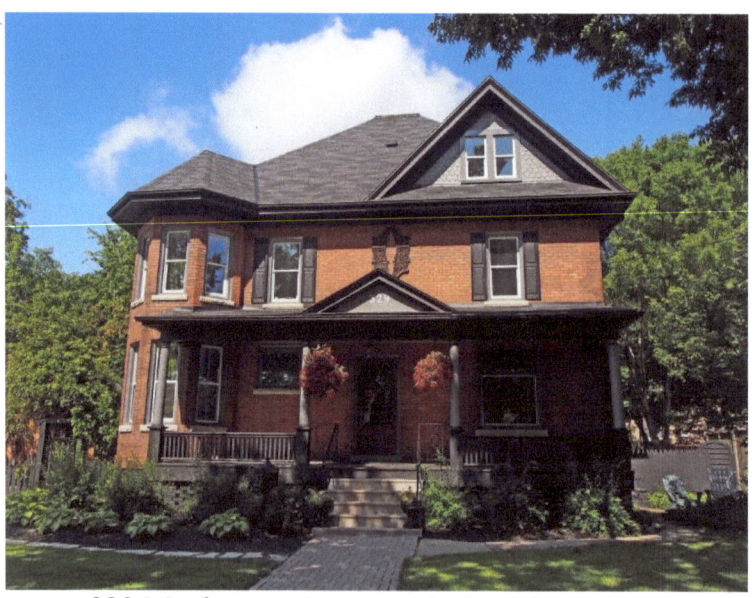

329 Mackenzie Street – 1910 – Edwardian, two-storey bay window

Mackenzie Street – gambrel roof, shed dormer, pediment above door, sidelights

336 Mackenzie Street – two-storey Italianate, dormer in roof

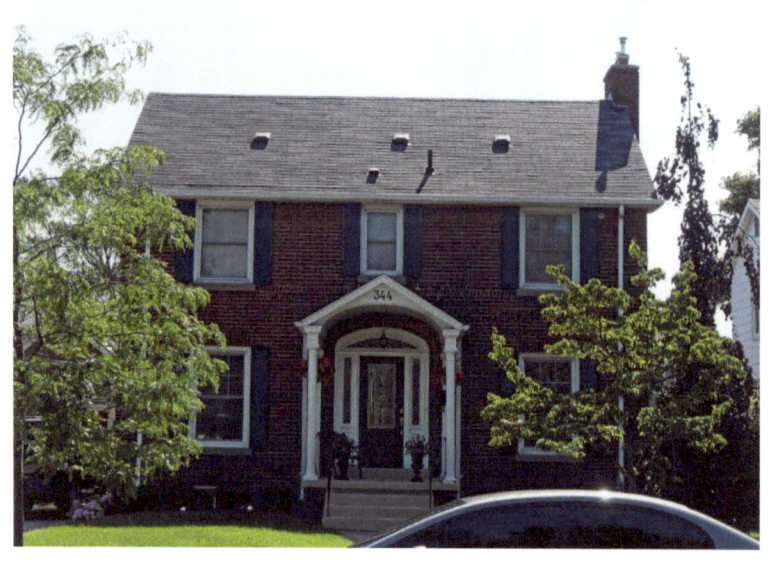

344 Mackenzie Street – Georgian, gabled roof

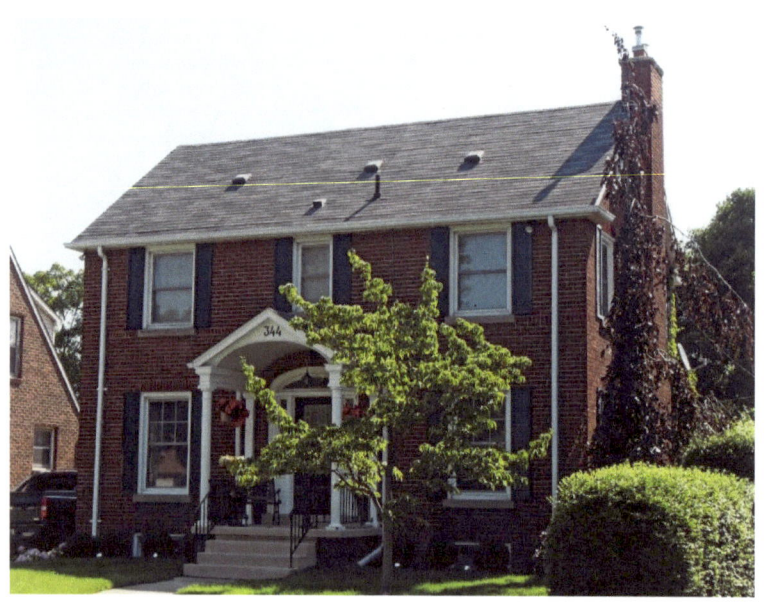

333 Mackenzie Street – one-storey Regency Cottage, oriel windows

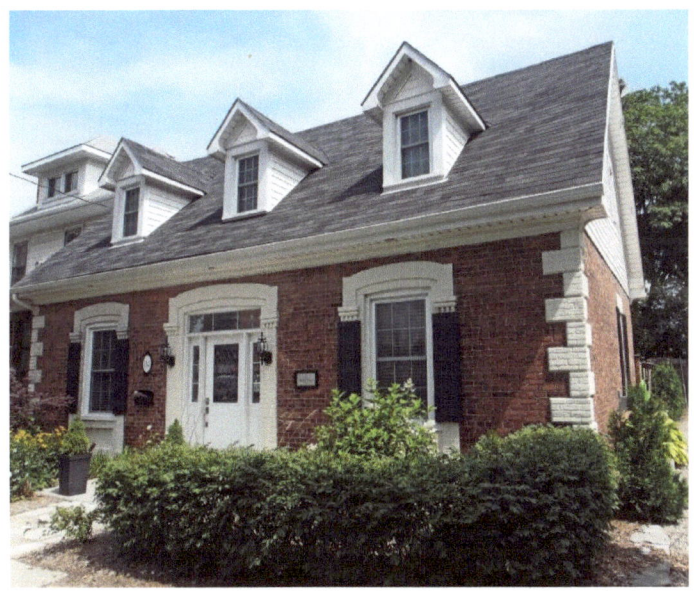

112 Maria Street – The Skilbeck House, 1834 – 1½-storey Ontario Regency cottage – white bricks in a quoining pattern at the corners, dormers in attic

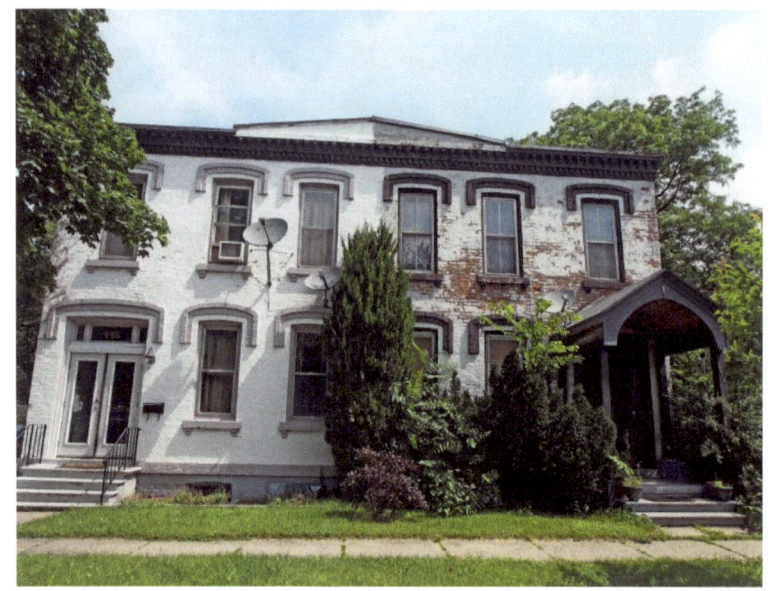

116-118 Maria Street – 1880 – voussoirs, dentil moulding

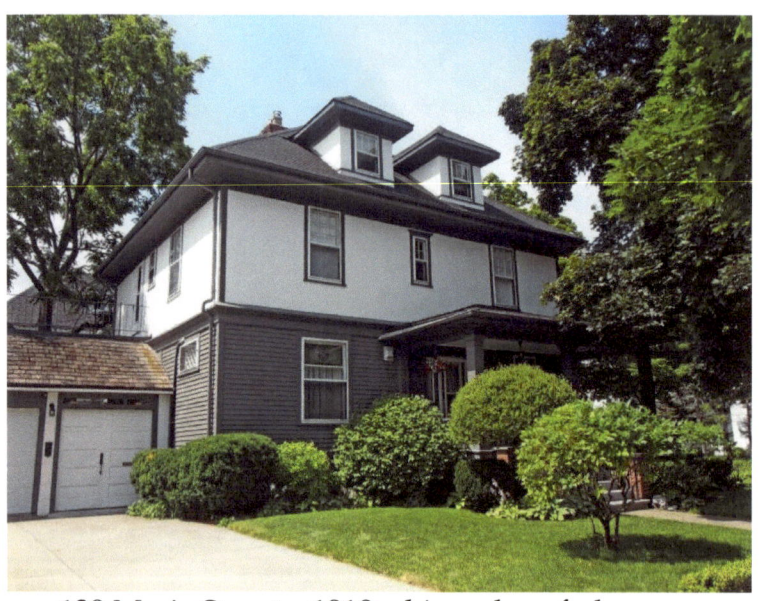

129 Maria Street – 1910 – hipped roof, dormers

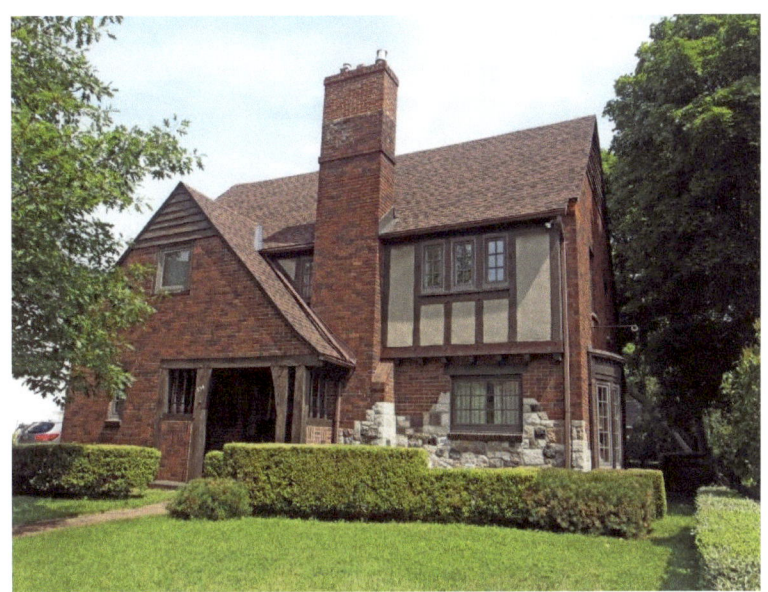

134 Maria Street – 1936 – Tudor

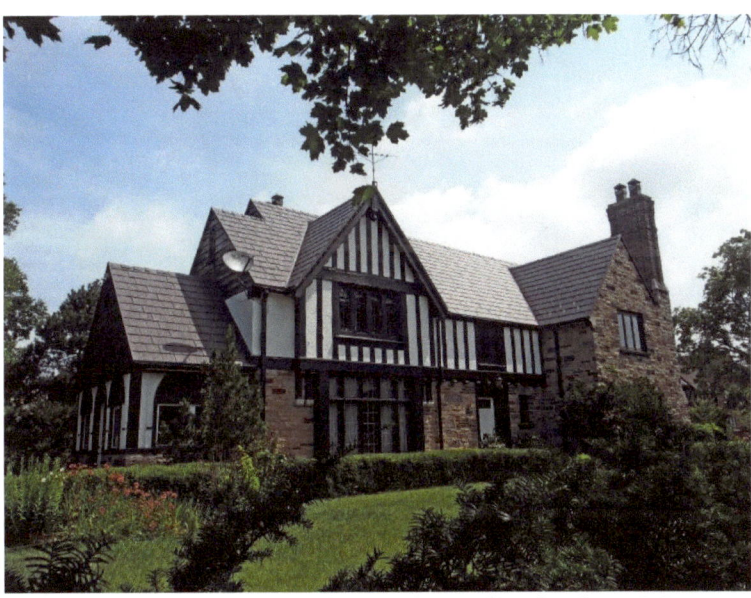

144 Maria Street – Tudor style – Elizabethan Manor

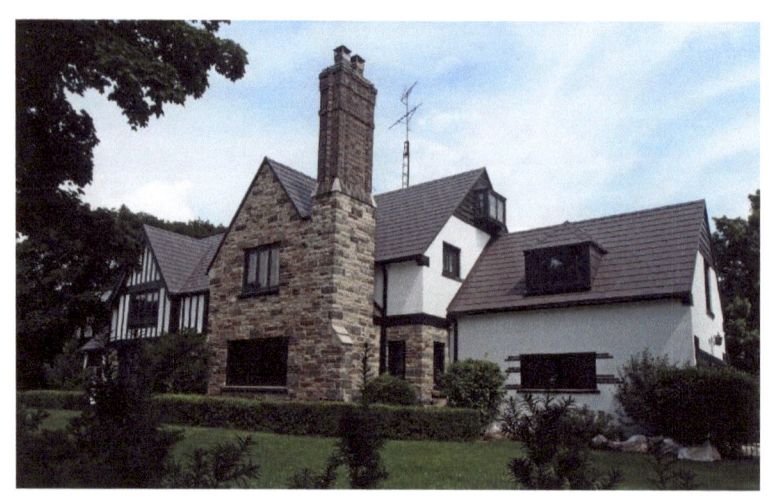

144 Maria Street

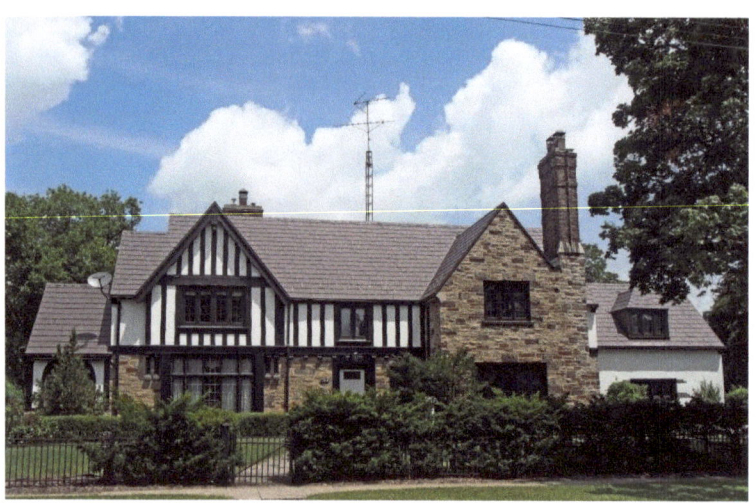

225 Maria Street – Regency Cottage

Maria Street – two-storey, hipped roof, dormer

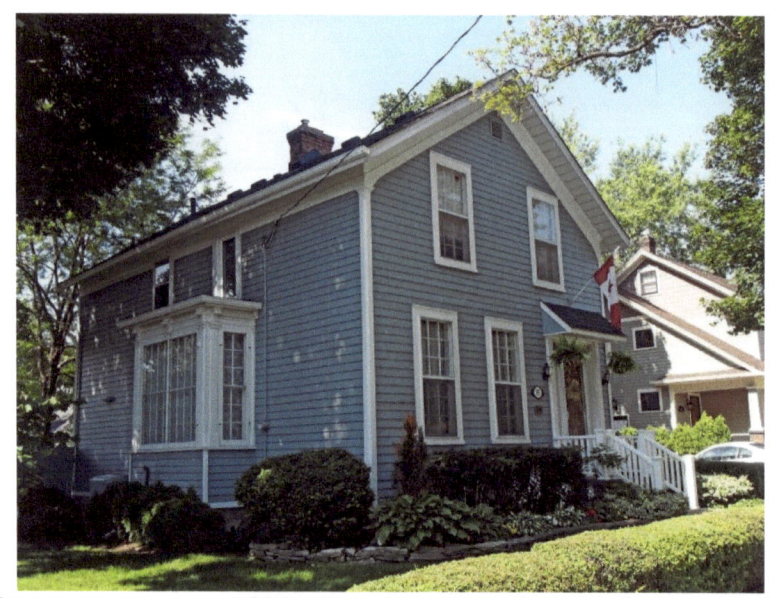

197 Maria Street – 1890 – 1½ storey, gabled roof, rectangular bay window on side

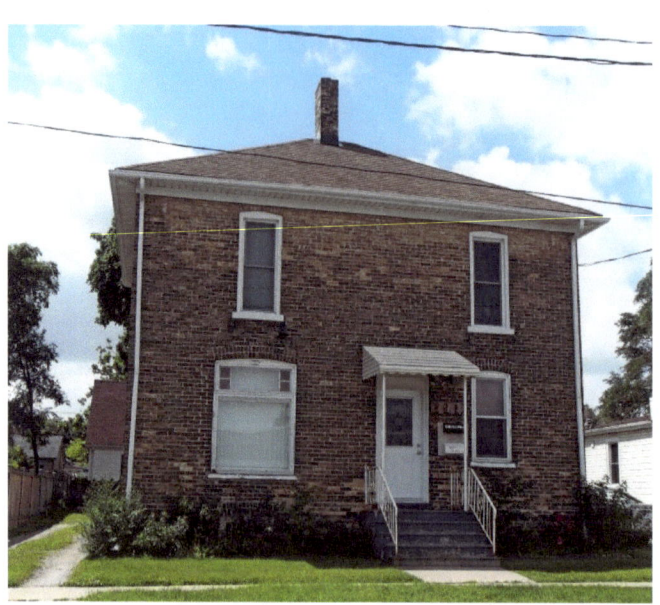

191 Maxwell Street – hipped roof

214 Napier Street – 1875 – Regency Cottage

129 Penrose Street – 1900 – Regency Cottage

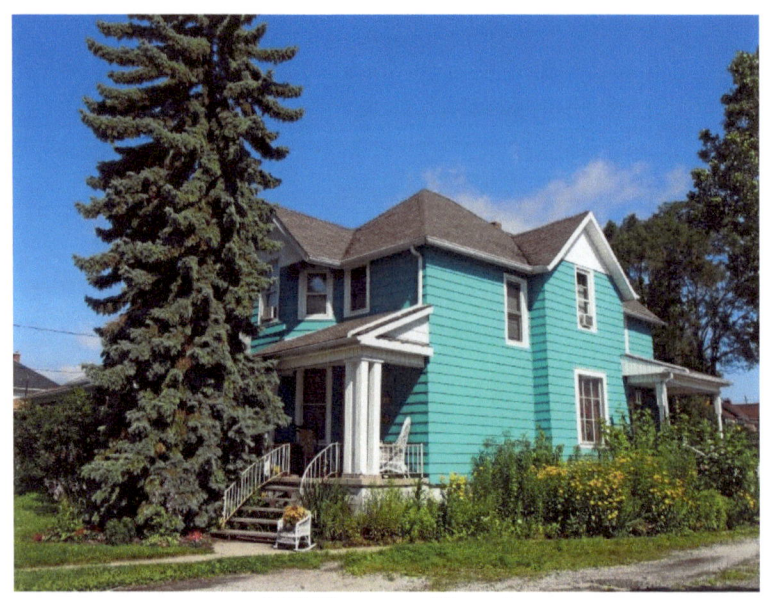

136 Penrose Street

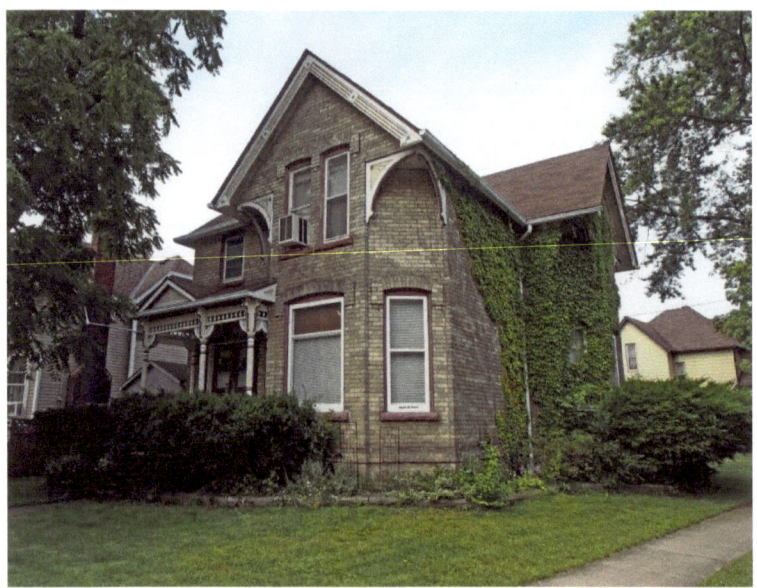

153 Queen Street – 1898 – Gothic Revival – fretwork, bric-a-brac and spindles on verandah, pediment, window voussoirs

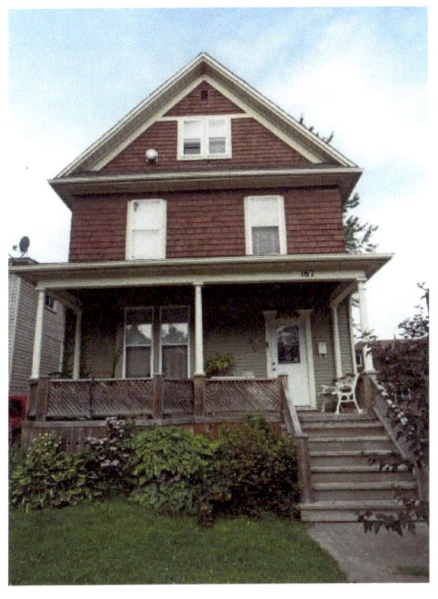

167 Queen Street - Edwardian

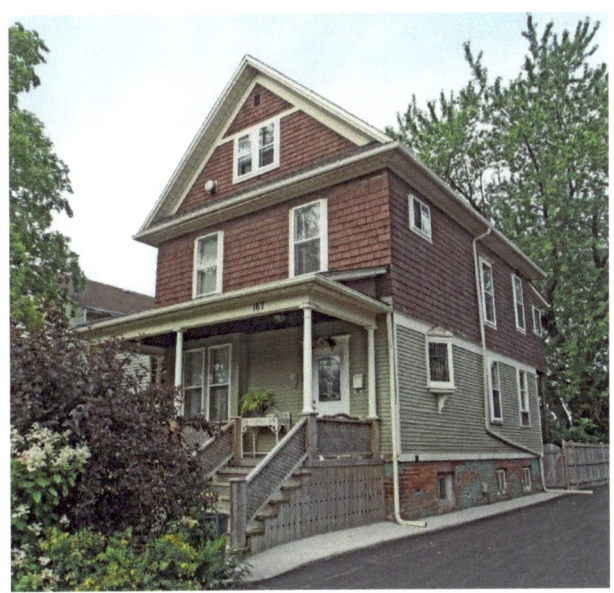

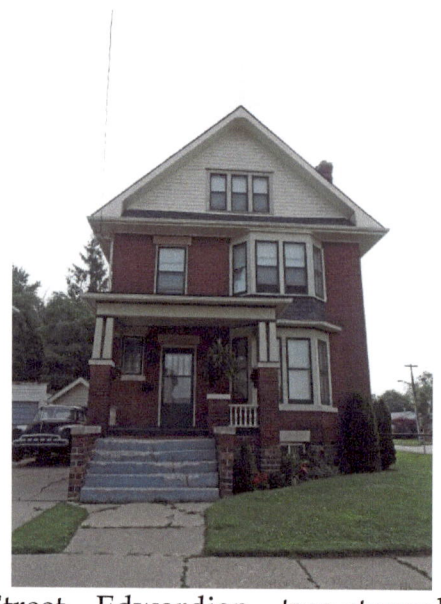

172 Queen Street – Edwardian – two-storey bay window

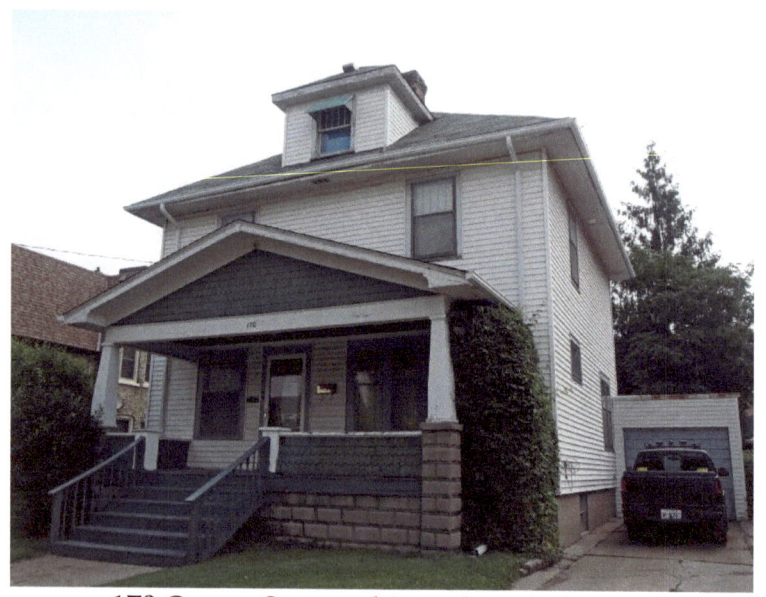

170 Queen Street – hipped roof, dormer

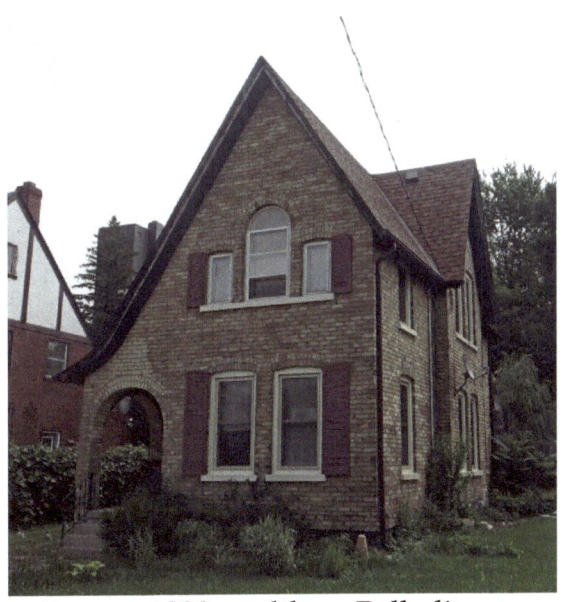

166 Queen Street – 1890 – saltbox, Palladian-type window

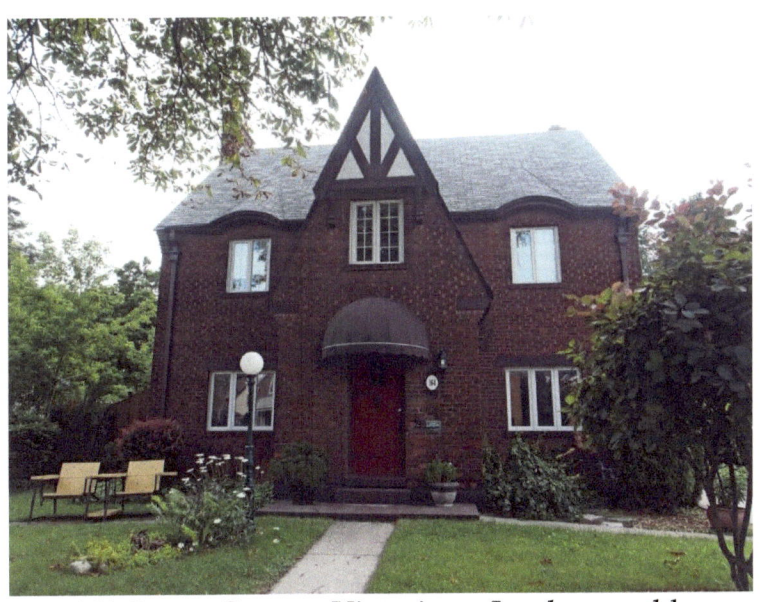

164 Queen Street – Victorian – Jacobean gable

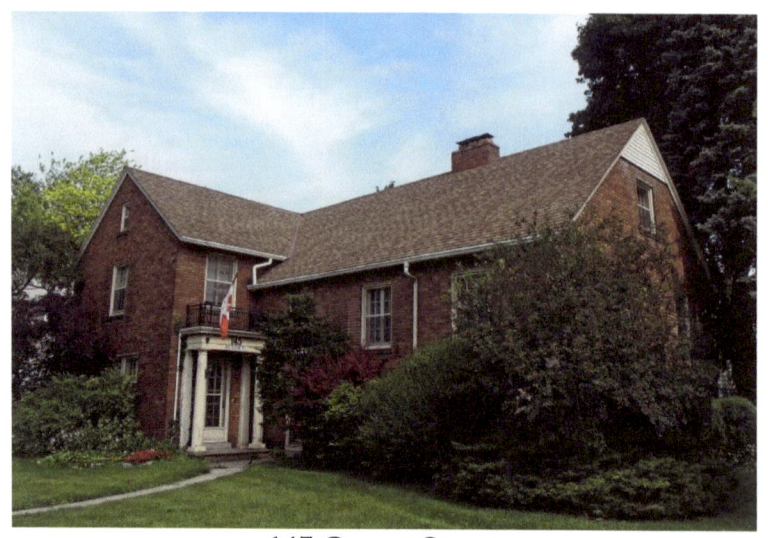
145 Queen Street

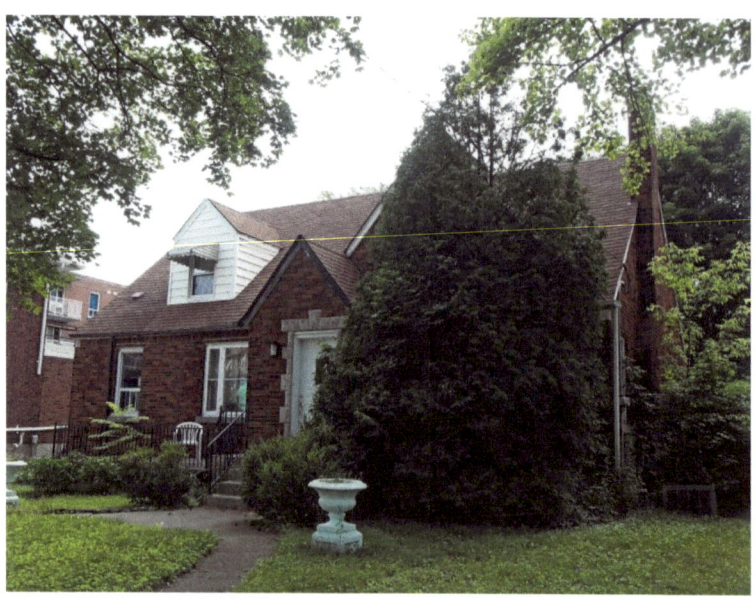
140 Queen Street - dormer

146 Queen Street - dormers

131 Queen Street – Gothic – bargeboard trim

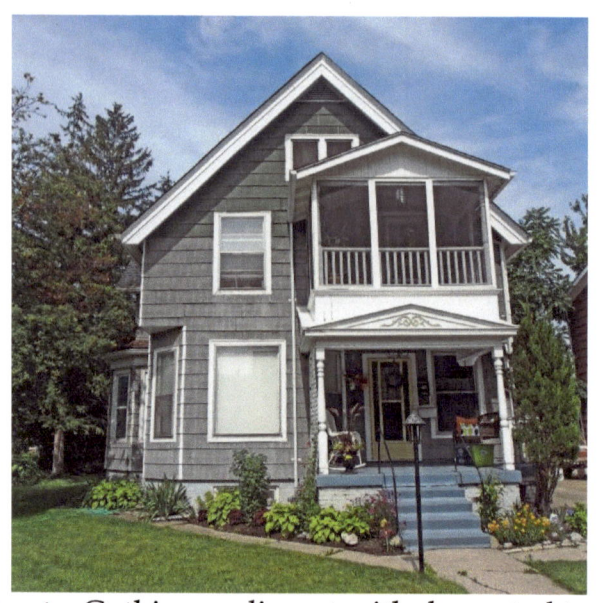

Queen Street – Gothic – pediment with decorated tympanum, bay window on side, screened in sleeping porch added above porch

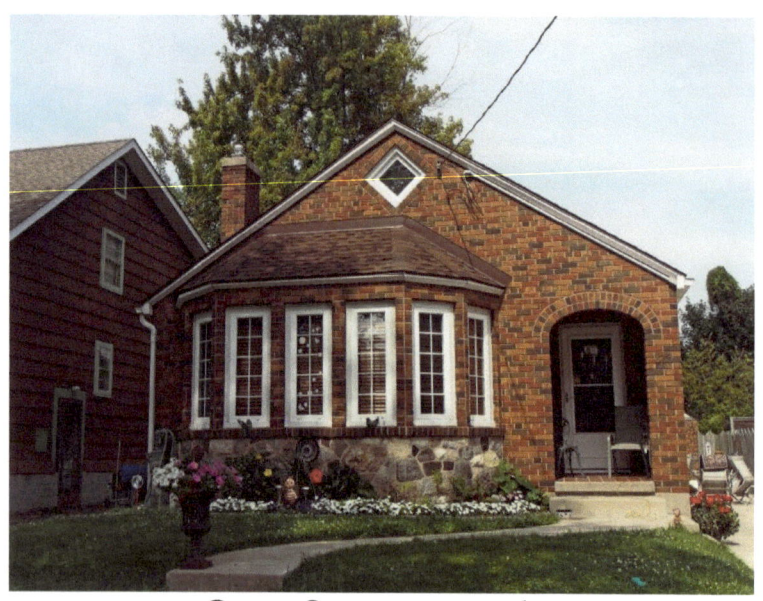

Queen Street - vernacular

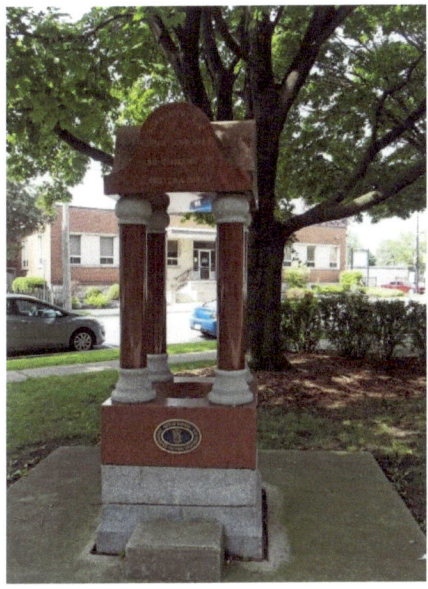
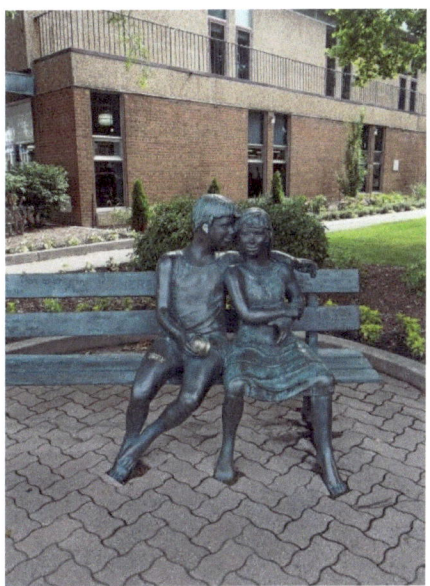

Sculpture at library

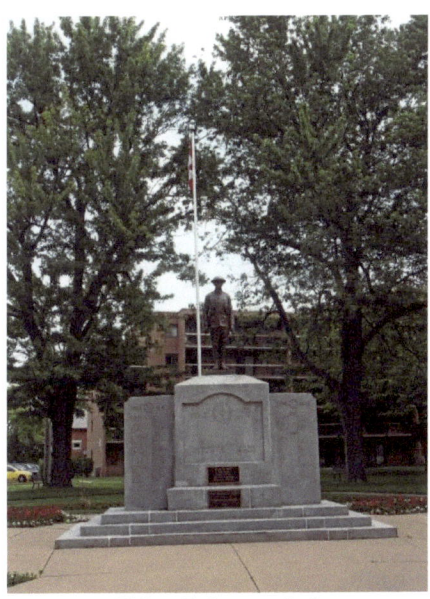

War Memorial

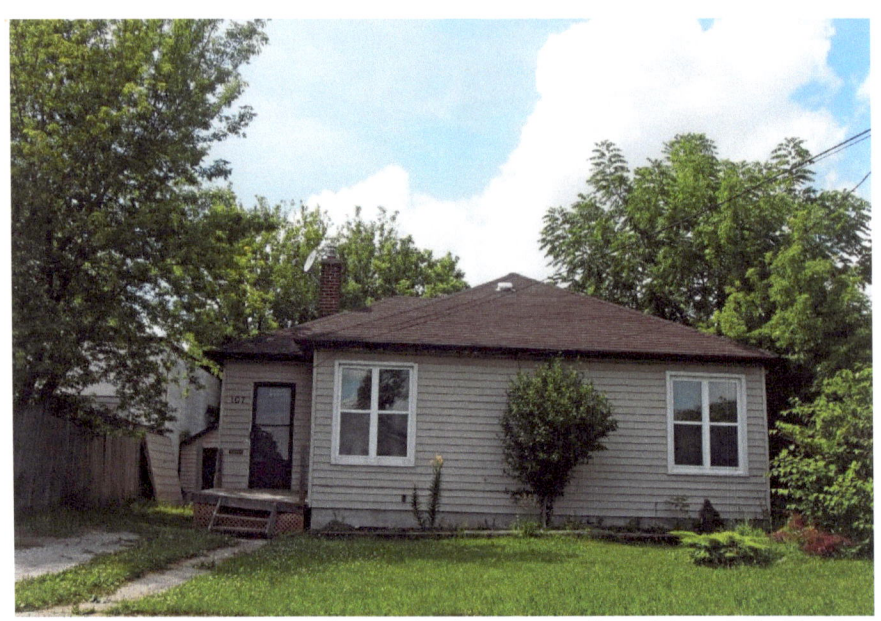

107 Rose Street – perhaps the house we lived in while Dad worked in Sarnia – one-storey cottage

129 Samuel Street - 1850

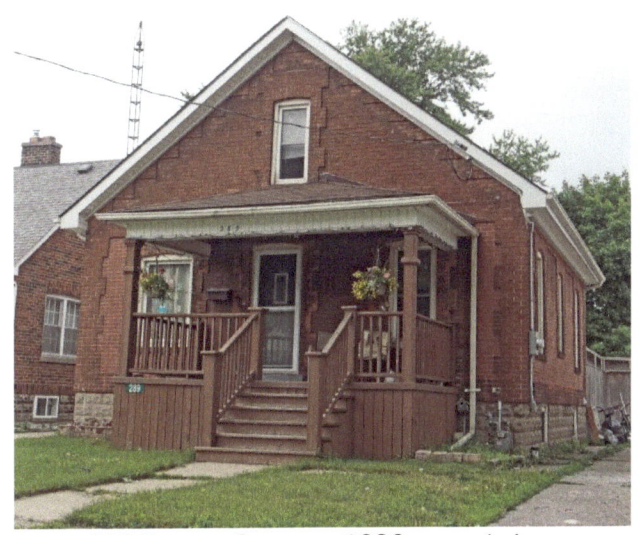

289 Savoy Street – 1920 - quoining

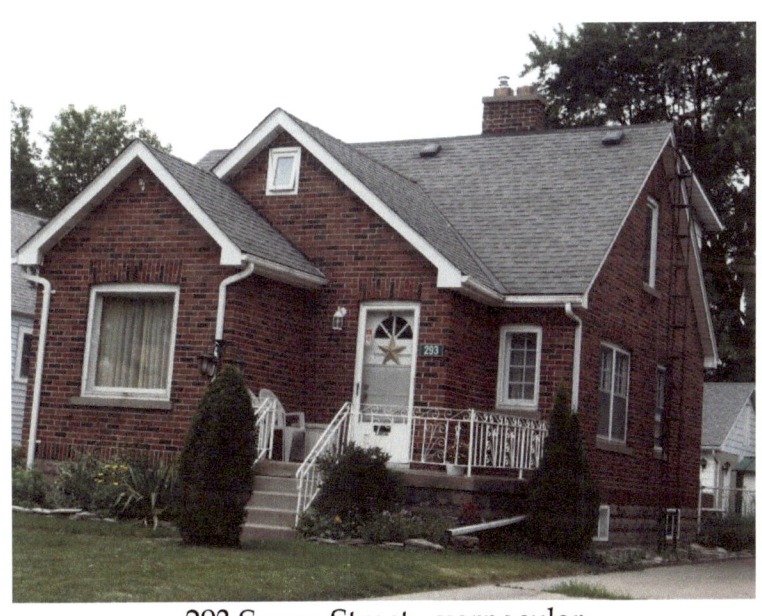

293 Savoy Street - vernacular

304 Savoy Street – two-storey Gothic

293 Stuart Street – Italianate – two-storey, dormer in hipped roof, full-width verandah, 2nd floor balcony

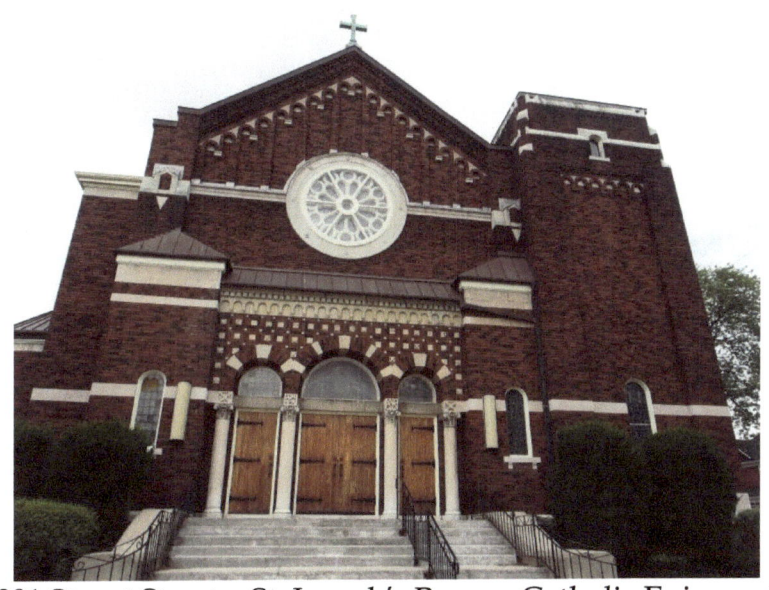

291 Stuart Street – St. Joseph's Roman Catholic Episcopal Church – 1928 – Spanish Colonial style – dichromatic brickwork, rose window, dentil moulding, Corinthian capitals on pillars, banding

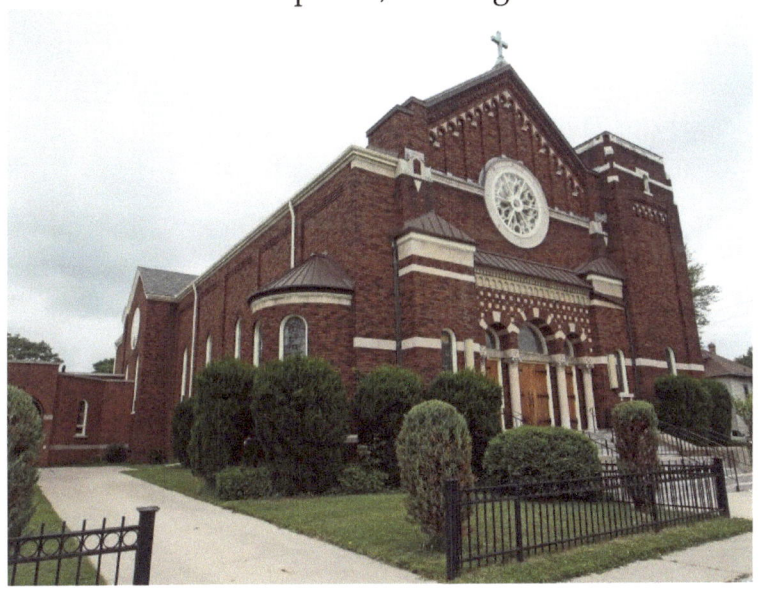

Architectural Terms

Banding: Different materials, colours or textures used in horizontal bands along a wall. Example: 291 Stuart Street, Page 53	
Bay Window: A window that projects out from a wall, in a semicircular, rectangular, or polygonal design. Used frequently in Gothic and Victorian designs. Example: 223 London Road, Page 32	
Brackets: a decorative or weight-bearing structural element which forms a right angle with one side against a wall and the other under a projecting surface such as an eave or roof. Example: 213 London Road, Page 13	
Capital: The uppermost finish or decoration on a column. A Corinthian column is characterized by a rounded capital decorated with acanthus leaves and a square abacus (the uppermost portion of a capital directly below the entablature) on tall slender columns. Example:	
Cobblestone architecture: Refers to the use of cobblestones embedded in mortar as a method for erecting walls on houses and commercial buildings. Example: 296 London Road, Page 28	
Dentil Moulding: an even series of rectangles used as ornamental decoration in cornices. Example: 116-118 Maria Street, Page 36	

Dichromatic brickwork: the use of two colours of brick, tile or slate to decorate a façade. Example: 291 Stuart Street, Page 53	
Dormer: (French for "sleep") a gable end window that pierces through the plane of a sloping roof surface to create usable space in the top floor or attic of a building by adding headroom. Example: 218 London Road, Page 14	
Entrance: The entrance encompasses the doorway and the inner vestibule or, in residential architecture, the covered porch. Example:	
Fretwork: interlaced decorative design resembling a bracket Example: 153 Queen Street	
Gable: the triangular portion of a wall between the edges of a sloping roof. Example: 297 London Road, Page 27 **Jacobean Gable:** the gable extends above the roofline. Example: 164 Queen Street, Page 45	

Gambrel Roof: a symmetrical two-sided roof with two slopes on each side; the upper slope is positioned at a shallow angle, while the lower slope is steep. It is similar to a mansard roof, but a gambrel has vertical gable ends instead of being hipped at the four corners of the building. Example: 424 London Road, Page 17	
Hipped Roof: a roof where all sides slope downwards to the walls with no gables. Example: 191 Maxwell Street, Page 40	
Iron Cresting: A decorative ornament along the top of a roof. Iron cresting was popular in the Baroque era and also in Italianate, Victorian, Second Empire and Queen Anne styles of architecture. Example: 322 London Road, Page 23	
Keystones and Voussoirs: a voussoir is a wedge-shaped element used in building an arch. A keystone is the central stone that locks all the stones into position, allowing the arch to bear weight. A keystone is often enlarged and embellished. Example: 297 London Road, Page 27	
Palladian Window: a large window that is divided into three sections with the centre section larger than the two side sections and usually arched. Example: 322 London Road, Page 23	

Pediment: a triangular section above the horizontal structure (entablature), typically supported by columns. The inside of the triangle is called the tympanum. Example: Queen Street, Page 48	
Quoin: masonry blocks at the corner of a wall, often a decorative feature, usually larger or of a different colour than the rest of the wall. Example: 481-483 London Road, Page 15	
Rose Window: a circular window with ornamental tracery radiating from the centre. Example:	
Sidelight: a window, usually with a vertical emphasis, that flanks a door, and is often used to emphasize the importance of a primary entrance. **Transom Window:** the light above the doorway, also called a fanlight. Example: 112 Maria Street	
Vergeboard and Finial: also called bargeboards – hang from the projecting end of a roof and are often elaborately carved and ornamented. **Finial:** ornament added to the top of a gable, pinnacle, canopy or spire – a Gothic element. Example: 223 London Road, Page 14	

Building Styles

Edwardian, 1900-1930 – This style bridges the ornate and elaborate styles of the Victorian era and the simplified styles of the 20th century. Balanced facades, simple roof lines, dormer windows, large front porches, and smooth brick surfaces are its characteristics. Example: 172 Queen Street, Page	
Georgian, before 1860 – This style began with the British King Georges in the 18th century. These buildings have balanced facades around a central door, medium-pitched gable roofs, and small paned windows. Example: 312 London Road, Page 24	
Gothic Revival, 1830-1890 – These decorative buildings have sharply-pitched gables with highly detailed verge boards, pointed-arch window openings, and dichromatic brickwork. It is a common style in Ontario. Example: 153 Queen Street, Page 42	
Italianate, 1850-1900 – It has wide-bracketed eaves, belvederes, wrap-around verandahs. Example: 213 London Road, Page 13	
Regency Cottage, 1830-1860 – This style originated in England in 1815 and spread to Ontario later in the 19th century as British officers retired to Canada. It is a modest one-storey house with a low-pitched hip roof and has a symmetrical front façade. Example: 129 Penrose Street, Page 41	

Saltbox: A saltbox is a building with a long, pitched roof that slopes down to the back, generally a wooden frame house. A saltbox has just one storey in the back and two stories in the front. The asymmetry of the unequal sides and the long, low rear roof line are the most distinctive features of a saltbox, which takes its name from its resemblance to a wooden lidded box in which salt was once kept. The earliest saltbox houses were created when a lean-to addition was added onto the rear of the original house extending the roof line sometimes to less than six feet from ground level. Example: 166 Queen Street, Page 45	
Tudor Revival – exposed timbers with stucco infill, multi-paned windows. Example: 144 Maria Street, Page 37	
Vernacular/Traditional Mode 1638 - 1950 Influenced but not defined by a particular style, vernacular buildings are made from easily available materials and exhibit local design characteristics. Example: 145 Johnston Street, Page 10	
Victorian - In Ontario, a Victorian style building can be seen as any building built between 1840 and 1900 that doesn't fit into any of the other categories. It encompasses a large group of buildings constructed in brick, stone, and timber, using an eclectic mixture of Classical and Gothic motifs. Example: 164 Queen Street, Page 45	

www.ingramcontent.com/pod-product-compliance
Lightning Source LLC
Chambersburg PA
CBHW040852180526
45159CB00001B/405

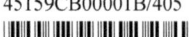